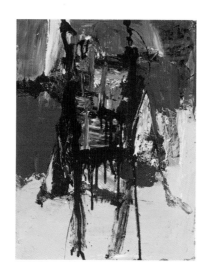

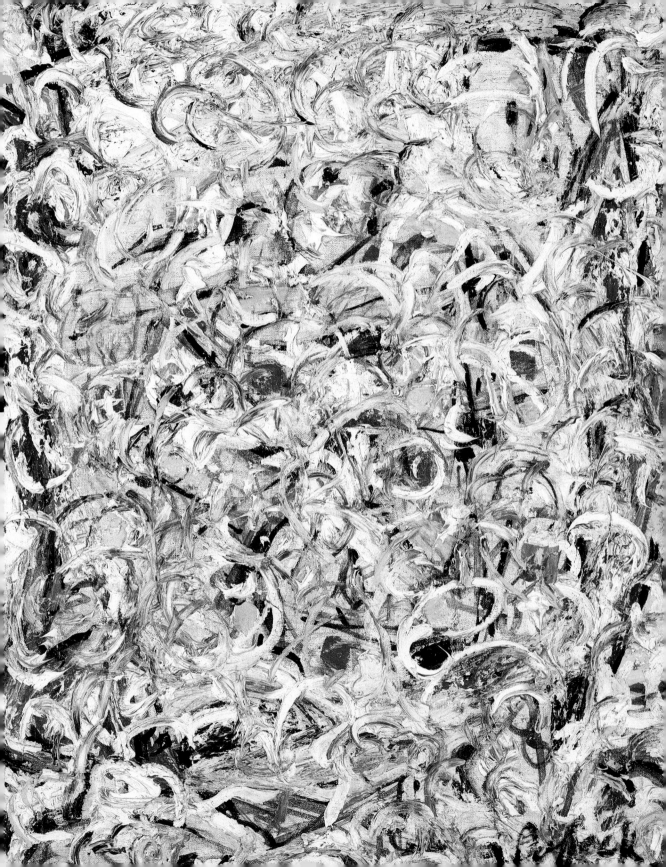

abstract
expressionism

BARBARA HESS
UTA GROSENICK (ED.)

TASCHEN

KÖLN LONDON LOS ANGELES MADRID PARIS TOKYO

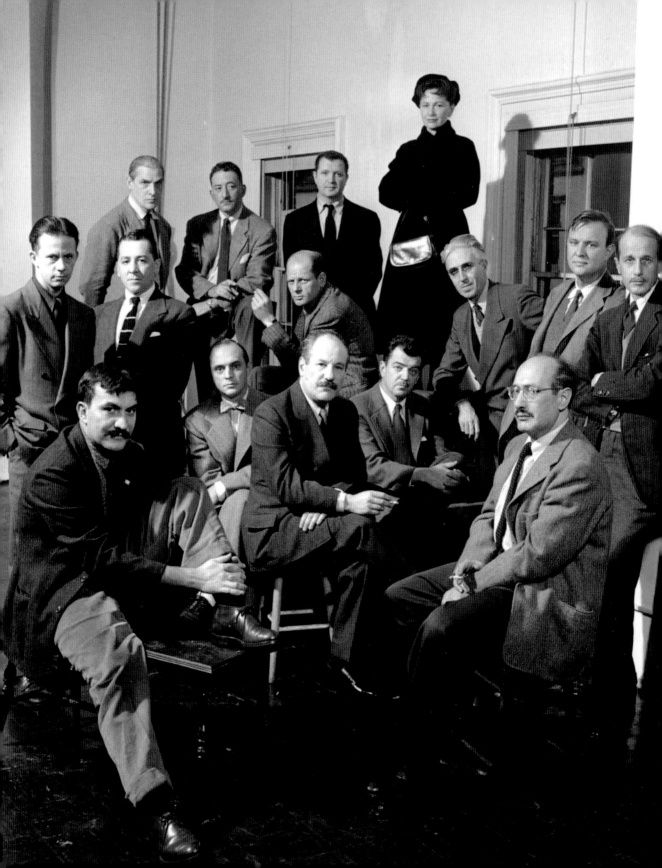

contents

"A constant searching of oneself"

"We agree only to disagree." According to Irving Sandler, writer and observer of the art scene, this was the unwritten motto of that loose grouping of artists in New York in the 1940s and 50s who are generally known as "Abstract Expressionists" or "the first generation of the New York School". In their statements and writings, insofar as they have been preserved, the artists usually considered to have belonged to this school resist being lumped together in this way, fearing that their very different views on art and aesthetic production would be suffocated if subsumed under a single stylistic description or group name. "It is disastrous to name ourselves," answered the painter Willem de Kooning in a panel discussion in 1950 when the former director of the New York Museum of Modern Art, Alfred H. Barr, Jr., demanded: "We should have a name for which we can blame the artists — for once in history!" Barr's remark was an allusion to the fact that most artistic "-isms" — such as for example Impressionism and Cubism — were coined by critics and often originally applied derisively.

"Abstract Expressionism" is no exception. On 30 March 1946 there appeared in the "New Yorker" a discussion of an exhibition in the Mortimer Brandt Gallery, the first comprehensive presentation of works by the painter Hans Hofmann, who had emigrated to the USA from Germany in 1932. The author of the review, Robert Coates, observed that until then the artist had been accorded little attention, and explained this in part by his painting technique: "For he is certainly one of the most uncompromising representatives of what some people have called the spatter-and-daub school of painting and I, more politely, have christened Abstract Expressionism."

Coates himself had borrowed this description from another author, probably Alfred Barr. The expression "Abstract Expressionism" had first turned up (in German) as far back as 1919 in the magazine "Der Sturm", which appeared in Berlin from 1910 to 1932 and was especially well known for its reproductions of Expressionist prints. In the USA, Alfred Barr first used this description in 1929 in relation to works by Wassily Kandinsky, who in about 1911 had abandoned any pretence at copying the world of objects. A few years later, in the catalogue to the 1936 "Cubism and Abstract Art" exhibition, Barr, from a formal perspective, distinguished between two traditions in abstract art: the first, more strongly geometric-structural tendency, in his view led from Georges Seurat and Paul Cézanne, via Cubism, to the various geometric and Constructivist movements in Russia and Holland, and had, since the First World War, become international. "The second — and, until recently, secondary — current," Barr continued, "has its princi-

1936 — Bombing of the Basque village of Guernica by the German Condor Legion, which was fighting on Franco's side
1937 — The "Degenerate Art" exhibition is held in Munich

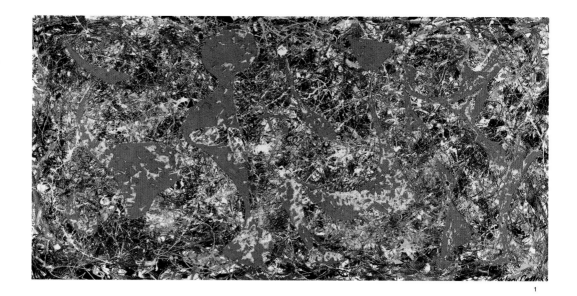

1

pal source in the art and theories of Gauguin and his circle, flows through the Fauvisme of Matisse to the Abstract Expressionism of the pre-war paintings of Kandinsky. After running under ground for a few years it reappears vigorously among the masters of abstract art associated with Surrealism. This tradition, by contrast with the first, is intuitive and emotional rather than intellectual; organic and biomorphic rather than geometrical in its form; curvilinear rather than rectilinear, decorative rather than structural, and romantic rather than classical in its exaltation of the mystical, the spontaneous and the irrational."

"тhe unwanted тitle"

In a certain sense, Barr's article was prophetic for many artists who, in the next two decades, were to attract increasing attention as the "New York School". Surrealism was one of the influential trends with which American artists were coming to terms, in particular when the coming-to-power of the National Socialists in Germany and the outbreak of the Second World War forced numerous exponents of the Surrealist movement to emigrate to the United States. New Yorkers were also acquainted with Wassily Kandinsky's early abstract works

through the collection in the Museum of Non-Objective Art, the future Solomon R. Guggenheim Museum. And so the term coined by Alfred Barr and re-introduced by Robert Coates gradually found currency. Among artists, though, it was always "The unwanted title", the motto of a symposium organized by the painter Phillip Pavia in 1952 for that celebrated association of New York artists known simply as The Club.

The more neutral geographical description New York School – in allusion and in contrast to the École de Paris, which until the 1940s had been regarded as the world-leader – was first applied primarily on account of New York's being the most important work and exhibition location for a new generation of artists. The name can be traced back to "The School of New York" exhibition which the artist Robert Motherwell organized in 1951 at the Frank Perls Gallery in Beverly Hills, and which included works by, among others, William Baziotes, Willem de Kooning, Adolph Gottlieb, Hans Hofmann, Robert Motherwell, Jackson Pollock, Richard Pousette-Dart, Ad Reinhardt, Mark Rothko, Theodoros Stamos, Hedda Sterne, Clyfford Still, Mark Tobey and Bradley Walker Tomlin.

The aesthetic content of what generally goes by the name of Abstract Expressionism occupies a singularly broad spectrum, and

1938 — In Germany the Nazis organize a pogrom against the Jewish population 1938 — Discovery of nuclear fission by Otto Hahn, whose colleague Lise Meitner had been forced to leave Germany shortly before on account of her Jewish ancestry

2. JACKSON POLLOCK

<u>Going West</u>
c. 1934/35, oil and plaster on canvas,
38.3 x 52.7 cm
Washington, D.C., Smithsonian American
Art Museum, Gift of Thomas Hart Benton

3. MARK ROTHKO

<u>Untitled (Subway)</u>
c. 1937, oil on canvas, 51.1 x 76.2 cm
Washington, D.C., National Gallery of Art,
Gift of The Mark Rothko Foundation, Inc.

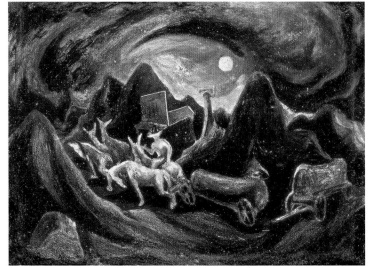

2

this proviso, with its reference to the decided "individualism" within the New York School, has been a kind of critical platitude since as long ago as the late 1950s. The visual differences range from the − in some cases − transparently overlaid colour veils such as those seen in Mark Rothko's paintings − their "abstractness" clear enough, their "expressiveness" less obviously so − via Willem de Kooning's series *Women* − "expressive" enough with their visible deployment of the body, but indisputably "figurative" in their adherence to the tradition of the female nude − right up to the legendary gestural "drip-paintings" of Jackson Pollock, in whose (literal) outpourings figurative elements can also sometimes be discerned.

The use of paint in the austerely composed, non-figurative pictures of Ad Reinhardt and Barnett Newman appears by contrast reticent and controlled. In his 1955 essay "'American-type' Painting", the influential critic Clement Greenberg noted, in respect of the large-format canvases employed by Rothko, Newman and Clyfford Still, a "more emphatically flat surface"; in their case, one also speaks of "Color Field Painting" − a term that, in addition, is used of the painting of the 1960s and 70s by such artists as Morris Louis, Kenneth Noland, Jules Olitski and Frank Stella, who worked in the aftermath of Abstract Expressionism.

It seems, then, to be neither possible nor productive to try to pin Abstract Expressionism down to a single aesthetic programme or a stable group identity. Accordingly, there seems little purpose in defining which artists are to be counted as "Abstract Expressionists", even though art historians have tried time and again to do so, with varying results. Alongside the figures already mentioned, we have included James Brooks, Arshile Gorky, Philip Guston, Franz Kline, Elaine de Kooning, Lee Krasner, the sculptor David Smith, and Mark Tobey among the "first generation of Abstract Expressionism"; while the "second generation" of younger artists, or of those who only developed their characteristic techniques in the 1950s, is supposed to include Friedel Dzubas, Sam Francis, Helen Frankenthaler, Grace Hartigan and Joan Mitchell. Like every canon in which works and interpretations defined as "worthy of being handed down" are listed, that of Abstract Expressionism is subject to historico-cultural revision. Without a doubt, the female Abstract Expressionists play a special role in this connection. The American art historian Marcia Brennan tellingly noted that women in Abstract Expressionism were "at the same time selectively present and strategically absent"; not until recently has greater attention been paid to the works and working conditions of artists such as Lee Krasner, Elaine de Kooning, Joan Mitchell or Janet Sobel.

September 1939 — Germany invades Poland; outbreak of the Second World War
1940 — German occupation of northern and western France, including Paris

"It is a widely accepted notion among painters that it does not matter what one paints as long as it is well painted. This is the essence of academicism. There is no such thing as good painting about nothing."

Mark Rothko

3

"myth-makers" and "ideographic pictures"

The prehistory of Abstract Expressionism begins in the late 1920s and early 1930s. After "Black Friday", the notorious Wall Street Crash of 25 October 1929, which triggered off a world economic crisis that was to last many years, America's economic strength fell to a historical low, and unemployment climbed to more than 30 percent. American art at this time was determined by two figurative tendencies: Regionalism, which took its motifs from the lives of the rural population, and Social Realism, which critically portrayed the darker sides of big-city life such as unemployment and isolation. The future Abstract Expressionists such as Mark Rothko and Jackson Pollock were influenced by these trends in the 1930s. Since the start of the decade, Pollock, for example, had been studying at the Art Students League with the Regionalist Thomas Hart Benton, whose influence is apparent in works like *Going West*; meanwhile Rothko was formulating his melancholy view of human existence in figurative symbolic big-city motifs such as subway and street scenes.

In order to counter the economic distress being suffered by artists, President Franklin D. Roosevelt's Works Progress Administration (WPA) instituted the Federal Arts Project (FAP) in 1935. This enabled numerous artists, including William Baziotes, Willem de Kooning, Arshile Gorky, Philip Guston, Lee Krasner, Jackson Pollock and David Smith, to earn a living from their art for the first time, while also promoting closer links between those involved. One important undertaking by the Federal Arts Project was the commissioning of works of art for public spaces, primarily exterior murals, whose execution was supervised by, among others, major representatives of the Mexican Muralist movement such as Diego Rivera, José Clemente Orozco and David Alfaro Siqueiros. While it is true that an artist like Arshile Gorky ironically described the social-critical orientation of the FAP's figurative wall-painting as "poor art for poor people", it was later to point the way ahead for the Abstract Expressionists' working methods using large-format canvases. Thus, with his 1943/44 *Mural*, Pollock created a painting of wall-filling size for the living-quarters of the collector and gallery-owner Peggy Guggenheim, and at the beginning of 1947, in his application for a grant from the Guggenheim Foundation, declared: "I believe easel painting to be a dying form, and the tendency of modern feeling is toward the wall picture or mural."

In the years 1936/37 the Museum of Modern Art staged two exhibitions which provided strong impulses for the younger generation of New York artists: "Cubism and Abstract Art" and "Fantastic Art,

1940 — The Russian revolutionary leader Leon Trotsky is murdered by the Soviet secret service while in exile in Mexico
1941 — The USA enters the war after the Japanese attack on Pearl Harbor

"The stuff of thought is the seed of the artist. Dreams from the bristles of the artist's brush. And, as the eye functions as the brain's sentry, I communicate my innermost perceptions through the art, my worldview."

Arshile Gorky

4

Dada, Surrealism". The latter, in particular, aroused an interest in the unconscious as a source of artistic expression, and in Surrealist artistic techniques such as "écriture automatique", a form of pictorial or written expression free of any censorship by the rational mind or the conscious will. Following the example of écriture automatique, the self-dynamic of the paint itself came to be increasingly important in the painting techniques of a number of Abstract Expressionists, for example through the use of highly diluted paint in Arshile Gorky's 1944 picture *One Year the Milkweed*, or in Jackson Pollock's drip-paintings. Pollock in addition emphasized his studies of the theories of Sigmund Freud and Carl Gustav Jung, who at the time enjoyed a broad following in the United States. In an interview with Selden Rodman in 1956, he remarked: "I'm very representational some of the time, and a little all of the time. But when you're painting out of your unconscious, figures are bound to emerge. We're all of us influenced by Freud, I guess. I've been a Jungian for a long time… Painting is a state of being… Painting is self-discovery. Every good artist paints what he is."

This view of painting as "self-examination, self-reassurance and self-expression" – a quotation from a panel discussion initiated by "Life Magazine" on the subject of "modern art" in 1948 – was defini-

tive for the Abstract Expressionists and their public alike. Mark Rothko, Adolph Gottlieb and Barnett Newman saw themselves, especially during the 1940s, as modern "myth-makers" who, by having recourse to "primitive" and archaic cultures – for example native American or pre-Columbian art – hoped to create timeless and immediately accessible metaphors and symbols for the condition of "modern man", which was perceived as tragic. Thus Newman, in his preface to the 1947 exhibition "The Ideographic Picture" at the Betty Parsons Gallery, referred to the art of the native peoples of North America and drew a direct parallel between their works and those of his fellow artists such as Hofmann, Rothko, Stamos and Still: "Spontaneous, and emerging from several points, there has arisen during the war years a new force in American painting that is the modern counterpart of the primitive art impulse."

In the early 1990s the American art historian Michael Leja drew attention to the importance, for the appearance of Abstract Expressionism, of the discourse concerning "modern man", which in 1930s' and 40s' America was being carried on in numerous popular science books and magazines: following the experience of the world economic crisis, social injustice and racial disturbances, the appearance of totalitarian regimes, the holocaust and the lapse into barbari-

1942 — In Germany, the systematic murder of the Jews is decided upon at the "Wannsee Conference"

1943 — Headed by the physicist Robert Oppenheimer, scientists and engineers in the USA work on an atomic weapons programme

4. ARSHILE GORKY

<u>One Year the Milkweed</u>
1944, oil on canvas, 94.2 x 119.3 cm
Washington, D.C., National Gallery of Art

5. JACKSON POLLOCK

<u>Composition with Pouring II</u>
1943, oil on canvas, 64.7 x 56.2 cm
Washington, D.C., Hirshhorn Museum and
Sculpture Garden, Smithsonian Institution,
Gift of Joseph H. Hirshhorn, 1966

6.

<u>Announcement of Jackson Pollock's exhibition:</u>
<u>"Paintings and Drawings"</u>
1943, in Peggy Guggenheim's gallery
Art of This Century

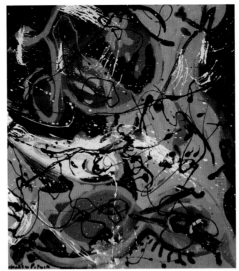

5

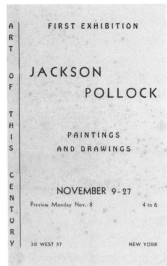

6

ty which it implied, the devastation wrought by the Second World War in general and the atomic bomb in particular, American society was dominated by a feeling of crisis concerning the image of humanity, doubt over what was meant by progress, and a questioning of the value of science and rational thought. In the discourse concerning "modern man" – who was implicitly seen as male, white and heterosexual – this crisis was not analysed as historically determined, but rather interpreted as pointing back to so-called "primitive cultures" as an anthropological constant. In this reference system, Abstract Expressionism could be seen – by its publicists such as gallery-owners, curators and critics, but also by collectors and a broader public – as a valid expression of this crisis of "modern man", and as a result, according to Leja, took on a central role in the cultural debate of the time.

An Art scene comes into Being

The gradual rise of Abstract Expressionism in the 1940s cannot be seen in isolation from the appearance of the New York art world, a dense network of new galleries, magazines, art schools and artist meeting-places. The story of an avant-garde art movement like Abstract Expressionism, would, according to the sociologist Diana Crane, have taken a fundamentally different course without the continuous expansion of this infrastructure – an expansion, which took place against the background of general growth in the American economy during the 1940s. Thus the painter Max Weber could still observe, in 1936, on the occasion of the "First American Artists' Congress Against War and Fascism" in New York, that artists were advised, at the start of their careers, to make contacts, but that at the end of their lives their only contact was mostly with the workhouse. Up till then, the demand for contemporary American art was not particularly strong; the market was dominated by European art.

Peggy Guggenheim, niece of the collector Solomon R. Guggenheim, had fled to New York from Europe in the company of Max Ernst in 1941 and opened her Art of This Century gallery in October 1943. There were, according to her colleague Sidney Janis, "maybe a dozen galleries in all of New York". By the early 1950s, according to the art historian and observer of the scene Dore Ashton, about thirty, and ten years later this figure had already increased more than tenfold.

1943 — German troops surrender at Stalingrad
1943 — Roosevelt, Churchill and Stalin agree on the invasion of occupied Europe from beachheads in northern France

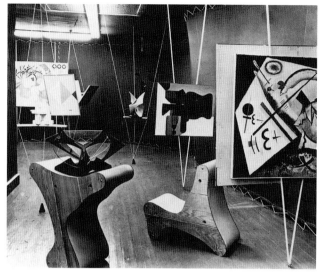

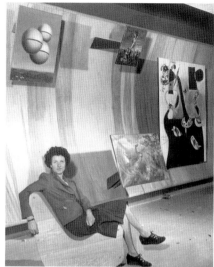

7

8

"The gallery had a slightly threatening look –
as though it the visitor could eventually find himself
pinned to the wall, while the art works wandered
around making their sweet or sour remarks respectively."

Edward Alden Jewell, "New York Times", on Art of This Century

In the Art of This Century exhibition rooms – designed by architect Frederick Kiesler as Surrealist environments capable of continual alteration – Peggy Guggenheim displayed not only her own collection of European Abstract and Surrealist art but, by the time of her return to Europe in 1947 had also staged the first solo exhibitions of the works of numerous American Abstract Expressionists, including Jackson Pollock, Hans Hofmann, Mark Rothko, Clyfford Still, William Baziotes and Robert Motherwell. Guggenheim supported the artists by buying their works and commissioning others, and also sold their works to major collections such as that of the Museum of Modern Art. On the occasion of the closing of Art of This Century, Clement Greenberg wrote: "I am convinced that Peggy Guggenheim's place in the history of American art will grow larger as time passes and as the artists she encouraged mature." He was to prove right.

The artist and dealer Betty Parsons, who opened her gallery in September 1946, took over some of the positions of Peggy Guggenheim's programme following the closure of Art of This Century, among them Pollock, Rothko and Still; in addition Barnett Newman curated exhibitions for her gallery. Parsons came from a patrician New York family, and in her youth had studied sculpture in Paris under Émile-Antoine Bourdelle and Ossip Zadkine, and in California under Alexan-

der Archipenko. Since the mid-1930s, she had exhibited her own works in New York galleries together with artists such as Theodore Stamos, Hedda Sterne and Adolph Gottlieb. Enthusiastic but not particularly businesslike, she lost many of her artists – one exception was Ad Reinhardt – to other dealers. In his preface to the catalogue for the Parsons Gallery tenth anniversary, Greenberg summed up as follows: "Mrs. Parsons is an artist's – and critic's – gallery: a place where art goes on and is not just shown and sold."

Another dealer widely appreciated by artists was Charles Egan. He had gathered his experience by dealing in works by the German Expressionists and the École de Paris, before opening his own gallery at the start of 1946; here, in 1948, he helped Willem de Kooning, who was by then already in his mid-forties, to stage his first successful solo exhibition. Two other influential protagonists of the up-and-coming New York gallery scene were Samuel Kootz and Sidney Janis. Before Kootz set up his gallery in April 1945, he had written a book about "New Frontiers in American Painting" (1943). His programme encompassed both European and American art; for example his inaugural exhibition included works by the French artist Fernand Léger, then living in American exile, along with others by William Baziotes and Robert Motherwell. By dealing in the works of established and high-

6.6.1944 — The D-Day landings by the Western allies in Normandy

25.8.1944 — Paris is liberated from German occupation

7.

<u>Art of This Century</u>
c. 1942, Peggy Guggenheim's gallery in New York

8.

<u>Peggy Guggenheim in her gallery</u>
1952

9. HANS HOFMANN

<u>Autumn</u>
1949, oil on canvas, 61 x 76.2 cm
New York, Brooklyn Museum of Art,
Bequest of William K. Jacobs, Jr.

"The ability to simplify means to eliminate the unnecessary so that the necessary may speak."

Hans Hofmann

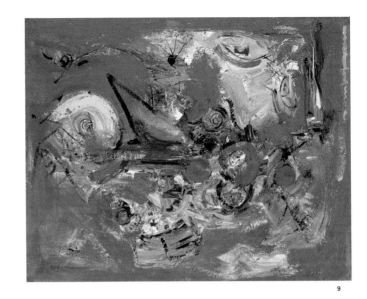

9

priced Europeans, above all Picasso, Kootz was able to build up a market for young and unknown American artists.

A similar strategy was pursued by Sidney Janis, whose gallery opened in the autumn of 1948. Janis' career in the art-world began as a collector of modern European art, including Pablo Picasso, Paul Klee, Fernand Léger, Henri Matisse, Giorgio de Chirico, Salvador Dalí and Henri Rousseau. In 1944, together with his wife, Harriet Grossman, he published a book on "Abstract and Surrealist Art in America", in which Pollock, Rothko, Motherwell and de Kooning were also included – artists whose works were later to feature in his gallery.

Alongside the galleries there appeared in the 1930s and 40s a series of non-commercial exhibition rooms, some of them organized by the artists themselves. An important location for an exchange of views was the art school set up in 1933 by the German émigré painter Hans Hofmann. Hofmann had lived in Paris between 1904 and 1914, and he put across to his pupils the basics of new European painting, in particular Cubism and Fauvism.

In the autumn of 1948 William Baziotes, the sculptor David Hare, Robert Motherwell, Mark Rothko and Clyfford Still founded an art school under the name of The Subjects of the Artists, with the aim of distancing themselves from their attribution to "abstract" art and

investigating the subjects of the "modern artist": "what his subjects are, how they are arrived at, methods of inspiration and transformation, moral attitudes, possibilities for further explorations, what is being done now and what might be done, and so on". After the financial collapse of The Subjects of the Artists, the activities of the school were continued by Studio 35, founded in the autumn of 1949.

Doubtless the most celebrated rendezvous was the artists' association known as the Eighth Street Club, called into being in the autumn of 1949 by twenty founder members, including Charles Egan, Franz Kline, Willem de Kooning and Ad Reinhardt. Until it closed in the spring of 1962, but in particular up until the early 1950s, it was a venue for discussions and lectures, some of which were published, promoting a lively exchange between a variety of protagonists: critics and writers, American and European artists, dealers and museum curators. They reinforced the conviction, in both the participants and their public, that the visual art created in America was of universal significance: a conviction which was also fired by the attention of the mass media, museums, and a new "nouveau-riche" class of collector starting to get interested in contemporary American art, and thus also Abstract Expressionist painting. As the critic Aline B. Louchheim put it in July 1944 in the magazine "ArtNews": "American paintings are

27.1.1945 — The Red Army liberates the Auschwitz concentration camp
February 1945 — At the Yalta Conference, the USA, Great Britain and the USSR decide to partition Germany into occupation zones

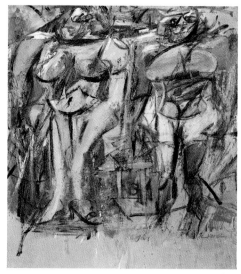

10. WILLEM DE KOONING

<u>Two Women in the Country</u>
1954, oil, enamel and charcoal on canvas,
117 x 103.5 cm
Washington, D.C., Hirshhorn Museum and
Sculpture Garden, Smithsonian Institution

11. ELAINE DE KOONING

<u>Al Lazar (Man in a Hotel Room)</u>
1954, oil on canvas, 75.6 x 62.9 cm
Courtesy the Estate.
Salander-O'Reilly Galleries, New York

12.

<u>Willem and Elaine de Kooning</u>
1953

cheaper, they are more plentiful, it is easier to find good ones, and it is seen as 'patriotic' to support American artists."

"Artists: man and wife"

In October 1949, the Sidney Janis Gallery organized an exhibition with the title "Artists: Man and Wife". Among the artist couples represented were Lee Krasner and Jackson Pollock, and Elaine and Willem de Kooning, along with the Europeans Ben Nicholson and Barbara Hepworth, and Hans Arp and Sophie Taeuber-Arp. The exhibition was thus a mise-en-scène, on two planes, of a kind of equality within a complicated situation of rivalry: both in the relationship between American and European art, and also within heterosexual artist relationships. In retrospect, however, Elaine de Kooning was, if anything, sceptical concerning the emancipatory impetus behind the idea of the exhibition: "There was something about the show that sort of attached women – wives – to the real artists. Well, maybe it was just too cute. You know, a cute idea; something to get attention for the gallery." As Elaine Fried, she had been a pupil of Willem de Kooning's in the late 1930s; they married in 1943. In spite of a

number of joint and solo exhibitions in the 1950s, Elaine de Kooning was at the time best known as a critic; in 1948 she joined the editorial staff of "ArtNews", the magazine which, under its new editor Thomas B. Hess, was devoting itself to the success of Abstract Expressionism.

A photograph of Rudolph Burckhardt dating from 1950 provides a visual image of the division of labour between the two married partners, though it is not difficult to imagine that in her role as critic Elaine de Kooning was certainly able to exert an influence on the work of the artist: Willem de Kooning seems to be hesitating as to which tube of paint to choose, while Elaine de Kooning watches him, pencil in hand. By contrast, in a later shot of the couple, by Hans Namuth, the artist's wife is literally in the background in relation to the artist: the centre of the photograph – and of the picture on the wall, from the series *Women*, a sequence of female nudes – seems to be taken up by no one apart from the painter himself.

In the same way, the emphatic placement of Hedda Sterne in the famous group photo of the Abstract Expressionists by Nina Leen comes across above all – in Elaine de Kooning's words – as a "cute idea": as the female exception, Sterne seems to lord it (so to speak) over her fourteen exclusively male fellow artists like a figurehead of

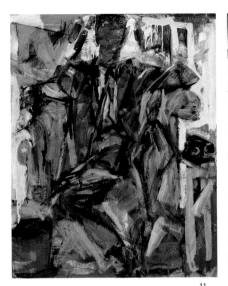

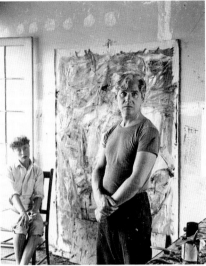

11

12

"The attitude that nature
is chaotic and that
the artist puts order into
it is a very absurd
point of view, I think.
All that we can hope for
is to put some order
into ourselves."

Willem de Kooning

the avant-garde, drawing all eyes to herself. The picture appeared in January 1951 in the popular magazine "Life" on the occasion of a protest letter by eighteen artists directed at the "American Painting Today – 1950" exhibition at the New York Metropolitan Museum. The signatories, known thenceforth as "The Irascibles", criticized the jury for not yet having given sufficient attention to "advanced art" in the planned exhibition. With their protest against the cultural establishment in the institutions, the "Irascibles" achieved their admission into the tradition of the avant-garde and, in addition, influenced the greater importance given to up-to-the-minute art in the exhibition: but works by female artists such as Hedda Sterne or Lee Krasner were still not included.

"primarily a Housewife": a Re-evaluation of the Female Artists

In its search for the "greatest living painter in the United States", by contrast, "Life Magazine" had, only two years earlier, already directed public attention, as though it went without saying, to a male figure: Jackson Pollock. As late as 1958, his wife Lee Krasner was, as Mar-

cia Brennan has pointed out, still being referred to in the same publication as "Mrs. Jackson Pollock", while in the same breath being designated "Hans Hofmann's best pupil" and at the same time described as "primarily a housewife". Artistic autonomy at that time, according to Marcia Brennan, was considered incompatible with female identity. The rivalry between the male Abstract Expressionists was fixated on individualism, and in this situation the female artists seemed predestined to a marginal role. "In each and every one of them," recalled Lee Krasner in an interview with Grace Glueck in 1982, "you knew how threatened he felt: the hostility was physically palpable. The whole culture's like that." The fact that Pollock respected her art was "the most you could ask for. But to expect that he would stand up to the whole culture and also to his fellow artists, that was going too far. Life was difficult enough as it was." And as late as 1961, five years after Pollock's death, Anita Brookner wrote in the respected "Burlington Magazine" in a discussion of the exhibition "The New York Scene" at the Marlborough New London Gallery: "Lee Krasner paints rather more spontaneously: the man is clearly a romantic." The absence of women in the area of Abstract Expressionism seemed at that time to be so self-evident that it never even occurred to the author to actually check the identity of Lee Krasner.

--

August 1945 — US President Harry S. Truman orders the dropping of atomic bombs on the Japanese cities of Hiroshima and Nagasaki

1945 — Occupation and division of Korea along the 38th parallel by the USSR and the USA

--

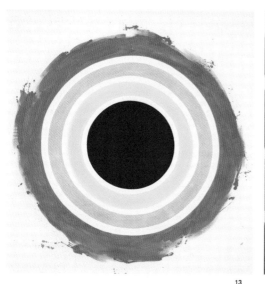

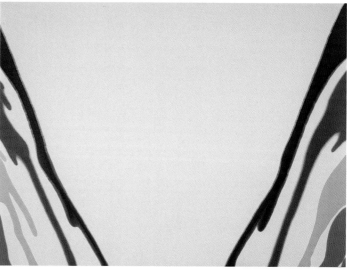

13

14

But for all that, Hedda Sterne, Elaine de Kooning and Lee Krasner, to name three female representatives of the first generation of Abstract Expressionism, had long been regularly exhibiting in New York galleries: Hedda Sterne had been represented by the Betty Parsons Gallery since 1947, where she had had regular solo exhibitions, and had also taken part in international group exhibitions, for example at the 1956 Venice Biennale; works by Elaine de Kooning were present in the 1950s not only in galleries, but also in museum exhibitions; Lee Krasner had been exhibiting regularly in New York since 1937, and had had her first solo exhibition at the Betty Parsons Gallery in 1951.

But anyone looking down the indexes of the anthologies of exhibition discussions and critical essays from these decades will find it difficult to discover any mention, let alone detailed discussion, of their works. In the public perception, they took a back seat to their male colleagues; this was especially true, when, like Elaine de Kooning or Lee Krasner, they promoted their husbands' careers and were reduced time and again to the role of eye-witnesses to the latter's production processes. But from this "testimony" it is nonetheless always possible also to discern their own contributions to the process by which the art of their male partners was created: for example,

when, in 1969, Lee Krasner reported that in the summer of 1950 Jackson Pollock had, with reference to a new work, posed the legendary question: "Is this a painting?"

In this connection, a certain special role is played by Helen Frankenthaler. She is perhaps the only female artist of the second generation of Abstract Expressionists who was admitted to have had a decisive influence on the subsequent development of non-figurative art. When the great definer Clement Greenberg was writing about the painting of Morris Louis and Kenneth Noland in the magazine "Art International" in 1960, he observed that Louis, having encountered the paintings of Jackson Pollock and Helen Frankenthaler's picture *Mountains and Sea*, had overcome the influence of Cubism and struck out on a new artistic course. Like Frankenthaler, from then on Louis worked on unprimed, unsealed canvases, which absorbed the runny paint, leaving the weave of the cloth visible. Kenneth Noland also left his canvases unprimed, concentrating on a non-gestural, non-figurative use of paint, which emphasized the visual over the haptic. Not long after, Greenberg described Frankenthaler's characteristic "soak-stain" painting technique using unprimed canvas (a technique reminiscent of watercolour) as pointing the way in a direction that he had christened "Post-Painterly Abstraction" in 1964. It was only after

1947/48 — The Truman Doctrine becomes the cornerstone of US foreign policy: "free" nations are to be given military and economic support to preserve their sovereignty. An economic recovery plan for Europe is initiated (the Marshall Plan)

13. KENNETH NOLAND
Half
1959, acrylic on canvas, 174 x 174 cm
Houston, Museum of Fine Arts

14. MORRIS LOUIS
Gamma Gamma
1959/60, acrylic on canvas, 260 x 386 cm
Düsseldorf, K20 – Kunstsammlung
Nordrhein-Westfalen

15. HELEN FRANKENTHALER
April
1963, Acrylic on canvas, 125 x 178.4 cm
Private collection

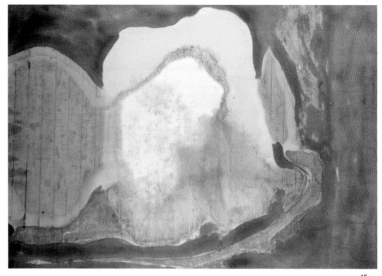

15

"I've explored a variety of directions and
themes over the years. But I think in my painting
you can see the signature of one artist,
the work of one wrist."

Helen Frankenthaler

Abstract Expressionism had ended its formative period in the mid-1950s, when its art-historical significance was no longer disputed and its market value was established, that the contributions of the female exponents were given rather more attention in hindsight, and their ongoing productions were also more frequently exhibited – a continuous process of re-evaluation, which is still going on today.

Art in the cold war

The history of Abstract Expressionism is closely bound up with that phase of post-war history known as the "Cold War". By the end of the Second World War at the latest, America – after a period of isolationism in the 1930s – was beginning to define herself as an economic and military power operating on the international stage, whose task was to defend the "free world" against the threat represented by the communist states of the Eastern bloc. At this stage, America still had a monopoly on nuclear weapons, whose destructive power was manifested, and engraved on the collective consciousness, by the atomic bombs dropped on Hiroshima and Nagasaki in 1945; this power was perceived as a potential threat of global dimensions. The

widespread fear of imminent extinction was reflected in different ways, also, in the artistic production of the Abstract Expressionists. Thus the "abstract" Jackson Pollock was expressly striving to take account, in his art, of the concrete situation of the age he was living in. In an interview with William Wright in 1950 he stressed: "It seems to me that the modern painter cannot express his age, the airplane, the atom bomb, the radio, in the old forms of the Renaissance or of any other past culture. Each age finds its own technique."

The role which Abstract Expressionism played in the complex domestic and foreign politics of the post-war period is extraordinarily multi-layered. Thus in the international exhibition business it functioned on the one hand as the official advertisement of a modern, liberal America, while at home it had no shortage of bitter opponents. Sections of the conservative nationalistic camp berated it as un-American, communist, or mentally sick. The most frequently quoted representative of this faction is probably the Republican congressman George Dondero, who in 1949 told the House of Representatives: "All these isms are of foreign origin, and truly should have no place in American art. While not all are the media of social or political protest, all are instruments and weapons of destruction." Dondero had certainly enough political clout to bring about the cancellation, in 1947, of an

1948 — Proclamation of the state of Israel by the Jewish National Council

1949 — Establishment of the North Atlantic Treaty Organization (NATO)

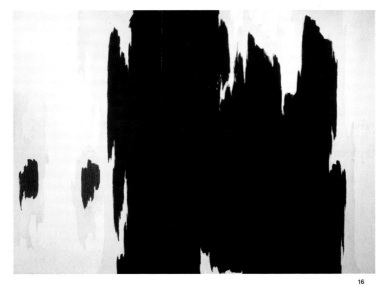

16. CLYFFORD STILL
<u>Untitled</u>
1956, oil on canvas, 288.8 x 410.2 cm
Private collection

17. BARNETT NEWMAN
<u>Who's Afraid of Red, Yellow and Blue IV</u>
1969–70, oil on canvas, 274 x 603 cm
Berlin, Neue Nationalgalerie

16

exhibition which had been touring Europe since 1946 under the title "Advancing American Art", alleging that some of the artists involved had formerly been communist sympathizers.

Dondero's pejorative phrase "the media of social and political protest" can certainly be applied to the socially committed American art of the 1930s, for example the Social Realism of the painting of Ben Shahn or the documentary photographs of Walker Evans, Robert Frank and Dorothea Lange. In that decade, numerous artists and intellectuals saw in socialism a way forward for society. Thus Clement Greenberg, at that time still under the influence of Trotskyism, wrote in "Avantgarde and Kitsch" in 1939: "Today we no longer look toward socialism for a new culture – as inevitably as one will appear, once we do have socialism. Today we look to socialism simply for the preservation of whatever living culture we have right now."

With the onset of the Cold War and in particular during the early 1950s, when the Republican Senator Joseph McCarthy was waging his notorious crusade against (in most cases, allegedly) communist artists and intellectuals, the debates of the Abstract Expressionists, their adherents and sponsors, seemed however to become largely depoliticized. "Oblique references abounded," remarked Dore Ashton, "but the fifties were not hospitable to art discussions with political ori-entation." This retreat on the part of artists was seen by art historians such as Serge Guilbaut as one of the reasons why their art could be reforged as a propaganda weapon in the Cold War, and why, to use Guilbaut's polemical expression, "New York was able to steal the idea of modern art": "The avant-garde artist who categorically refused to participate in political discourse and tried to isolate himself by accen-tuating his individuality was co-opted by liberalism, which viewed the artist's individualism as an excellent weapon with which to combat Soviet authoritarianism. The depoliticization of the avant-garde was necessary before it could be put to political use, confronting the avant-garde with an inescapable dilemma."

A New American style of painting?

In the mid-1930s, the art historian Meyer Schapiro, who taught in New York, could still observe that the term "American art" was nec-essarily inexact, feigning a fictitious unity. In the art criticism of the 1940s and 50s, by contrast, more intensive efforts were made to assert the aesthetic overcoming of European models and the supe-riority of modern American painting. Thus in January 1948 Clement

1949 — The Soviet Zone of Germany becomes the communist "German Democratic Republic"
1949 — The first Soviet nuclear test; the USA loses its nuclear monopoly; a "balance of terror" between East and West

"Aesthetics is for the artist like ornithology is for the birds."

Barnett Newman

Greenberg proclaimed, in "The Situation at the Moment" in the magazine "Partisan Review": "As dark as the situation still is for us, American painting in its most advanced aspects – that is, American abstract painting – has in the last several years shown here and there a capacity for fresh content that does not seem to be matched either in France or Great Britain." One logical problem in this debate, however, consisted precisely in the difficulty of discerning the specifically "American" aspect of the new painting in the face of its broad spectrum of artistic positions. Greenberg tried to resolve this in his 1955 essay "American-type Painting". His thesis was that modern painting had made it its goal to investigate its own material conditions and to filter out "the expendable conventions" of the medium, "in order to maintain the irreplaceability and renew the vitality of art": indeed, in order to ensure its viability. And this attack on the conventions of painting – such as three-dimensionality, illusionism, figure-background relationships – Greenberg saw successfully implemented above all in Abstract Expressionist painting, which at the same time was the first American art movement that was not only respected in Paris, but even imitated.

The message that Abstract Expressionism had overturned European models was still being enthusiastically proclaimed in the early 1960s, when the battles had already long been fought and the overwhelming importance of American art at home and abroad was no longer in dispute. In his 1961 essay "The Abstract Sublime", the American art historian Robert Rosenblum took it upon himself to yet again position Jackson Pollock, Clyfford Still, Mark Rothko and Barnett Newman, with their large-format canvases, inviting the beholder to contemplation, as the challengers of the "international domination of the French tradition, with its family values of reason, intellect, and objectivity", and to establish them as the legitimate successors of the Romantic tradition of the 19th century.

In so doing, critics like Greenberg in no way overlooked the fact that Abstract Expressionism in America owed its development since the early 1940s to numerous international interactions. The question "Have We an American Art?", which the art critic of the "New York Times", Edward Alden Jewell, posed in a 1939 book of that title, could not be answered in a single sentence. Numerous artists in the field of Abstract Expressionism, such as Arshile Gorky, John Graham, Hans Hofmann, Willem de Kooning, Mark Rothko and Hedda Sterne, were European émigrés, as were Rudolph Burckhardt (from Switzerland) and Hans Namuth (from Germany), whose photographs and films created the public image of the Abstract Expressionists that we still have

1949 — Mao Tse-tung proclaims the People's Republic of China
1950 — Outbreak of the Korean War between North and South Korea and their respective allies

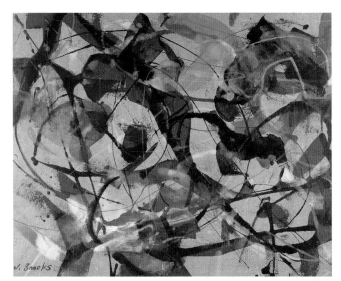

18. JAMES BROOKS

<u>Number 27, 1950</u>
1950, oil on canvas, 94 x 116.8 cm
New York, Whitney Museum of American Art,
Purchase with funds from
Mr. and Mrs. Roy R. Neuberger

19. HEDDA STERNE

<u>Roads</u>
1957, acrylic spray on canvas, 218 x 127 cm
Collection of the artist

20.

<u>"The New American Painting"</u>
1958–59, an exhibition that toured eight European
countries, organized by the Museum of Modern Art

today. Other protagonists, such as Betty Parsons and Sam Francis, studied or worked at least for a time in Europe. And alongside the numerous works by European artists in New York galleries and museums, it was in particular the presence of international artists, especially after the outbreak of the Second World War, that promoted an intensive cultural dialogue.

Nevertheless, the mostly positive reactions to Abstract Expressionism in the Europe of the late 1950s were often celebrated back home as an American "triumph". Among the places in which the new American painting was effectively staged were the Venice Biennale: its architectural structure with individual national pavilions in a spacious garden-setting continues even today to promote the perception of art on the nation-state principle. In 1950 there could be seen here, selected by the Museum of Modern Art, exhibitions by, among others, Arshile Gorky, Willem de Kooning and Jackson Pollock; in 1958 Mark Rothko exhibited in the American pavilion.

Pathbreaking in terms of its creation of international recognition of American painting as a new and significant artistic phenomenon was, not least, a comprehensive touring exhibition entitled "The New American Painting", with works by Baziotes, Brooks, Francis, Gorky, Gottlieb, Guston, Hartigan, Kline, de Kooning, Motherwell, Newman, Pollock, Rothko, Stamos, Still, Tomlin and Tworkow from the collection of the Museum of Modern Art; it was shown in 1958/59 in Basel, Milan, Madrid, Berlin, Amsterdam, Brussels, Paris and London, and finally, in a sense as a climax of a successful mission, presented in the Museum of Modern Art itself.

This "triumph" of the new American painting was finally sealed at the second documenta in Kassel in 1959, which was then, geographically, close to the border of the former (communist) East Germany. Both the American documenta contribution and the touring exhibition had been organized by the Museum of Modern Art's "International Program", which in the 1950s started a cultural-policy offensive directed not only towards Europe, but also other continents, at the centre of which Abstract Expressionism stood as the hallmark of the Western world's freedom of expression. When the art historian Eva Cockcroft, in an article published in 1974 in the magazine "Artforum" under the title "Abstract Expressionism, Weapon of the Cold War", questioned the ideological, economic and political background that had contributed to the success of Abstract Expressionism, the cover of the catalogue "The New American Painting, as Shown in Eight European Countries, 1958–1959" served to illustrate her thesis. In the same spirit, the German art historian Will Grohmann, in his

1950 — The USA witnesses the systematic denunciation of alleged communists under Senator Joseph McCarthy
1952 — The USA tests the first hydrogen bomb

"There are as many images as eyes to see."

Sam Francis

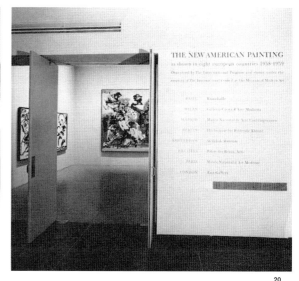

19 20

1958 review of this exhibition, had already described the Americans as "world-travellers and conquerors" and asked, rhetorically, whether Europe was already in a state of cultural defensiveness. And indeed the exhibitions organized by the "International Program" not only made a major contribution to America's being accorded a dominant role in the cultural sphere, but also sketched out an image of the artist as an individual struggling with social conventions, but ultimately apolitical. Thus Alfred Barr, in his preface to "The New American Painting", wrote: "They defiantly reject the conventional values of the society which surrounds them, but they are not politically *engagés* even though their paintings have been praised and condemned as symbolic demonstrations of freedom in a world in which freedom connotes a political attitude." While abstraction was identified with the artistic language of a "free world", Realism was indiscriminately equated with the art-form of the totalitarian regimes of National Socialism and Communism. Just as misleading was Barr's assertion that the Abstract Expressionist artists were all apolitical; in fact, some of them, including Philip Guston, Elaine de Kooning, Ad Reinhardt and Mark Rothko, supported the civil rights and anti war movements.

Even though, as mentioned at the outset, the identity of the first generation of Abstract Expressionists as an artist-group, stylistic trend or representatives of a genuinely "American" art cannot be summed up by any one term, they do have at least one thing in common: their international institutional and economic success. "An older generation of major [artists] […] may have made American painting exportable in the first place," was Greenberg's résumé in 1960.

"Apocalypse and wallpaper"

The point in time from which Abstract Expressionism can be counted as a recognized art movement – whether already from the late 1940s, or from about 1952 with the exhibition "Fifteen Americans" at the New York Museum of Modern Art, or only in the mid-1950s – is debatable. Serge Guilbaut, for example, sees Abstract Expressionism as being established as early as 1948, when, following the American presidential election of that year, the "New Liberalism" established itself, an ideology whose values – freedom, risk, humanism – accorded with the ideals which the avant-garde works of the Abstract Expressionists seemed to embody. A later important caesura for the institutional and economic success of Abstract Expressionism was undoubtedly Jackson Pollock's fatal accident in

1953 — Death of Stalin

1953 — The Soviet Union tests its first hydrogen bomb

1954 — West Germany becomes a member of NATO

21.

<u>Jackson Pollock</u>
in front of his painting "Summertime", 1948,
in: "Life Magazine", 8 August 1949

22.

<u>The New Soft Look</u>
photographed during Pollock's exhibition at the
Betty Parsons Gallery, November/December 1950,
in: "Vogue", March 1951

23. JACKSON POLLOCK

<u>Autumn Rhythm: Number 30, 1950</u>
1950, oil on canvas, 266.7 x 525.8 cm
New York, The Metropolitan Museum of Art,
George A. Hearn Fund, 1957

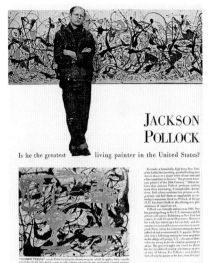

21

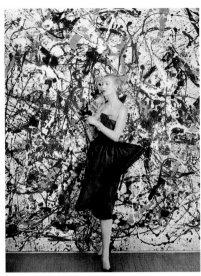

22

August 1956; the death of the major protagonist seemed to mark an endpoint in the development of the movement, which was reflected in the art market by a drastic increase in prices for Pollock's works and for those of some of his contemporaries.

If, however, the integration of Abstract Expressionism into the cultural mainstream, and into the output of the mass media, is to be regarded as an indicator of its broad acceptance, then March 1951 surely marks an important milestone in this process. That was the month in which the American fashion magazine "Vogue" published fashion photographs taken by Cecil Beaton at the end of 1950 at Jackson Pollock's exhibition at the Betty Parsons Gallery – against a background of pictures considered to be Pollock's "major works". It can easily be imagined that Harold Rosenberg had these photographs in his mind's eye when he wrote his article about "The American Action Painters", which appeared in "ArtNews" in November 1952. Rosenberg's essay is often quoted, because he coined the term "Action Painting" and disseminated Pollock's metaphor of the canvas as "an arena in which to act" – ideas that, to this day, are associated above all with the pictures of Franz Kline, Willem de Kooning and Jackson Pollock himself. In fact Rosenberg avoided mentioning any artists' names in his article, perhaps because he did not wish to push

their market value any higher. Rosenberg was influenced by Existentialism and, in his view, painting ought to be a place of free expression for an individual alienated from society; in a climate of increasing material consumption, however, it had become a commodity like any other. "Here the common phrase, 'I have bought an O' (rather than a painting by O) becomes literally true," noted Rosenberg. "The man who started to remake himself has made himself into a commodity with a trademark."

Particularly for a series of younger artists, who by now were almost mechanically reproducing the painterly idiom of the first generation, and also for their public, Abstract Expressionism was threatening to become a decorative cliché. "The result," noted a chastened Rosenberg, "is an apocalyptic wallpaper." The rise of Abstract Expressionist painting to vogue status is veritably incarnated in Cecil Beaton's photographs for "Vogue" magazine: his staging of elegant photographic models against Pollock's drip-paintings did indeed transform the latter in a sense into an "apocalyptic wallpaper" – although it should be said that Pollock himself did not object to the presence either of his person or of his works in the mass media.

Although Rosenberg tried to attribute a politically oppositional, even revolutionary, impulse to the new American painting, he could

1955 — Foundation of the Warsaw Pact as a counterbalance to NATO
1955 — The German city of Kassel becomes the venue for the first documenta exhibition of contemporary art

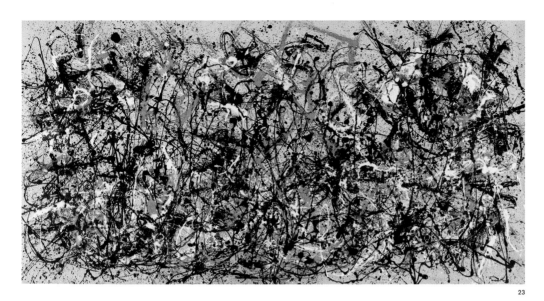

"I have no fears about making changes, destroying the image, etc., because the painting has a life of its own."

Jackson Pollock

not deny that the artists' sphere of influence, their "arena", was largely confined to the canvas: "The revolution against the given, in the self and in the world, which since Hegel has provided European vanguard artists with theories of a New Reality, has re-entered America in the form of personal revolts. Art as action rests on the enormous assumption that the artist accepts as real only that which he is in the process of creating."

The following years saw a rise in the warnings that Abstract Expressionism was threatening to become academic. The Club was the venue in 1954 and 1958/59 for a number of panel discussions under the titles "Has the Situation Changed?" and "What is the New Academy?". In this connection Alfred Barr even called in 1958 for a "revolution" on the part of the rising generation against the "young academy", as Dore Ashton recalls.

The fact that Barr, as the former director of the Museum of Modern Art, and still very much involved with the place, was at that time handing down judgement, as it were, from the summit of the Olympus of modernism, evokes the ambivalent picture of an aesthetic revolution from above. In addition, it soon became clear that Alfred Barr had not only called on younger artists to stage a "revolution" against Abstract Expressionism, but that the Museum of Modern Art

was supporting this revolution through its exhibitions, purchases and symposia.

"after abstract expressionism"

In fact some younger artists had already long since declared their attitude towards the generation of the Abstract Expressionists. Thus Robert Rauschenberg, who had exhibited at the Betty Parsons Gallery in 1951, asked Willem de Kooning in 1953 for a drawing which he could erase and present as his own work – a multiple ambiguous strategy in which the eradication of the famous original, intervention in its creative process, and a new aesthetic are combined. And also in Rauschenberg's famous statement, "Painting relates to both art and life. Neither can be made (I try to act in that gap between the two)", we still hear the echo of Harold Rosenberg, who in 1952 had declared: "The new painting has broken down every distinction between art and life." In 1948 Rauschenberg had started to study at Black Mountain College in North Carolina; his teachers included the influential composer John Cage, who had spread abroad the philosophy of Zen Buddhism and expounded new artistic principles, such as

1956 — Communist East Germany joins the Warsaw Pact
the Batista dictatorship in Cuba

1956 — Fidel Castro inaugurates his rebellion against
1957 — The USSR launches the first artificial satellite, the Sputnik

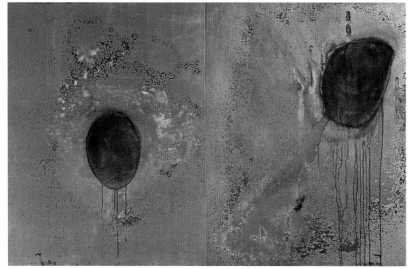

the integration of chance into artistic production, the parity of status between artist and public, and the close mutual-exchange relationship between art and life.

It was in particular the relationship between high art and everyday culture that was the object of revision in many ways during the late 1950s, and in this connection, the view of art inherent in Abstract Expressionism was also subjected to close examination. Thus the English critic Lawrence Alloway, in his 1958 article "The Arts and the Mass Media", suggested dropping the rigid distinction between authentic avant-garde art and mass media "ersatz culture", a distinction insisted upon by modernist critics such as Clement Greenberg. In this article, Alloway coined a term that was soon to be adopted for a new, internationally successful movement: Pop Art.

If we try to date the end of the era of Abstract Expressionism – on various levels such as production, art criticism, and the art market – more precisely, there is a good case for the year 1962. In October, the Sidney Janis Gallery – which had previously helped artists such as de Kooning, Motherwell, Pollock and Rothko to achieve their big breakthroughs – aroused widespread public attention with its exhibition "The New Realists". The title alluded to the "Nouveau Réalisme" movement in France, christened thus by Pierre Restany.

Janis' exhibition united works by nearly forty European and American artists, including Yves Klein, Arman and Niki de Saint Phalle, along with Roy Lichtenstein, Claes Oldenburg and Andy Warhol; critics like Harold Rosenberg saw in this exhibition the dawn of a new era in the American art world. The change of programme at Sidney Janis had far-reaching consequences: Willem de Kooning, Mark Rothko, Franz Kline and Robert Motherwell terminated their collaboration with the gallery. At the same time, Clement Greenberg observed in the magazine "Art International" that the current period appeared to be "gradually the age after Abstract Expressionism". And so Hans Hofmann's 1962 picture *Memoria in Aeterne* comes across as a melancholy, perhaps also defiant memorial picture, which he dedicated to the memory of those fellow artists of his generation who had died young: Arthur B. Carles, Arshile Gorky, Jackson Pollock, Bradley Walker Tomlin and Franz Kline.

If one attempts to explain what the importance and fascination of Abstract Expressionism are based on today, one factor is certainly its wide-ranging and hitherto ongoing effect on succeeding artistic developments. Indeed the relationship between the first generation of the New York School and the art of the 1960s and 70s – from Pop and Minimal Art via Happenings, Action Art and Body Art – right up to

1958 — The National Aeronautics and Space Administration (NASA) is set up in the USA **1959 — Following his**
successful revolt, Castro sets up a socialist system in Cuba **1961 — John F. Kennedy becomes president of the USA**

24. ANDY WARHOL

Oxidation Painting (detail)
1978, mixed technique and copper metallic paint
on canvas, 3 panels, 127 x 321.3 cm
Private collection

25.

Martin Kippenberger at work on "Schlecht belegte
Studentenpizza gepollockt" ("Badly topped student
pizza, pollocked") in Innsbruck, 1993
Martin Kippenberger Estate
Galerie Gisela Capitain, Köln

26. PAUL MCCARTHY

Painter
1995, Video still
Courtesy of the artist
Hauser & Wirth, Zürich, London

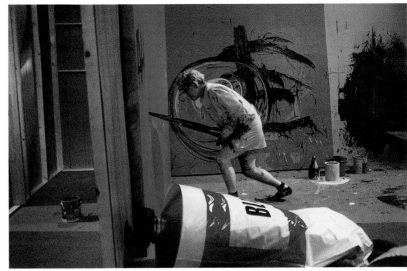

26

"If you pick up some paint with your brush and make
somebody's nose with it, this is rather ridiculous when you think
of it, theoretically or philosophically. It's really absurd to make
an image, like a human image, with paint, today."

Willem de Kooning

the present day can be described not primarily as a rupture, but rather as a productive confrontation. The artistic works which point express-ly to Abstract Expressionism, in order to transcend it, are extraordinar-ily numerous. In painting, they extend from Roy Lichtenstein's series of *Brushstrokes* and Andy Warhol's *Piss Paintings* (1961) and *Oxy-dation Paintings* (1977/78) to Frank Stella's *Die Fahne Hoch!* (1959), to name only a few of the best known examples.

An important take-up point for new developments was also formed by the extension of the "arena in which to act" into three-dimensional space: for example in the Happenings staged by artists such as Allan Kaprow and Carolee Schneemann, who both expressly invoked Jackson Pollock. More recently, references to Abstract Expressionism and its "heroic" figures have in some cases evinced analytical traits, such as for example in Louise Lawler's 1984 photo-graph *Pollock and Tureen, arranged by Mr. and Mrs. Burton Tremaine, Connecticut*, which directs our gaze to the "arranging" of art by private collectors; sometimes they come across as half-ironic, half-identificational homage, such as Martin Kippenberger's *Schlecht belegte Studentenpizza, gepollockt* (Badly Topped Student Pizza, Pollocked, 1993) or Paul McCarthy's 1995 video *Painter*, in which a figure with a blonde wig – an allusion to Willem de Kooning – shows

painting as a physical, sexualized practice, which has less to do with the expression of freedom than with the acting out of psychological compulsions.

"After the first burst of anti-Abstract Expressionist diatribes in 1962," noted the critic Lucy Lippard in 1970, "it became evident that this withdrawal from the principles of Abstract Expressionism was largely based on admiration and respect for that movement: it had been done too well to continue." In view of the ongoing art-historical and artistic concern with Abstract Expressionism, it could just as well conversely be maintained, however, that "it had been done too well" to end.

1961 — Trial of war criminal Adolf Eichmann in Jerusalem **1961 — East Germany builds the Berlin Wall**
1962 — The USSR promises to provide Cuba with military support

The Moon-woman cuts the circle

Oil on canvas, 109,5 x 104 cm
Paris, Musée national d'art moderne, Centre Pompidou

**b. 1912 in Cody,
d. 1956 in East Hampton (USA)**

"Pollock was not a 'born' painter. He started out as a sculptor, at sixteen, but before he was eighteen had changed over to painting. He had to learn with effort to draw and paint." This was how in 1967 Clement Greenberg, on the occasion of a posthumous retrospective at the Museum of Modern Art, outlined the start of the career of Jackson Pollock, who died in 1956 as a legend in his own lifetime.

Pollock studied from 1930 to 1933 at the New York Art Students League. His teachers included the Regionalist Thomas Hart Benton, who put his stamp on Pollock's early, figurative style of the 1930s. In a 1944 questionnaire, Pollock described his work with Benton as "important as something to react upon very strongly, later on; in this, it was much better to have worked with him than with a less resistant personality who would have provided a much less strong opposition". In the same questionnaire, Pollock emphasized the influence on his work of his origins in the American West, the broad horizontal expanse of the country as well as the art of the native American peoples: "The Indians have the true painter's approach in their capacity to get hold of appropriate images, and in their understanding of what constitutes painterly subject-matter. Their color is essentially Western, their vision has the basic universality of all real art." To the question concerning the importance of the famous European artists living at that time in the USA, Pollock answered: "I am particularly impressed with their concept of the source of art being the unconscious. This idea interests me more than these specific painters do, since the two artists I admire most, Picasso and Miró, are still abroad."

The Moon-Woman Cuts the Circle, dating from 1943, is, together with *Mad Moon-Woman* (1941), and *The Moon-Woman* (1942), one of three pictures painted in the early 1940s in which Pollock concerned himself with the motif of the Moon-Woman; all three were exhibited at his first solo exhibition at Peggy Guggenheim's Art of This Century gallery in November 1943. The figure's head-dress points to native American culture, details like the silhouette and the eyes to Pablo Picasso's 1937 anti-war picture *Guernica*, the contrast-rich coloration to paintings by Joan Miró.

Pollock's mention in 1944 of the "basic universality of all real art" which he saw in the native American cultures of the American West recalls C. G. Jung's idea of a "collective unconscious" transcending cultures and common to all human beings. Pollock had undergone psychotherapy at the hands of a Jungian from 1939 to 1942, primarily on account of his alcoholism. In Jung's theory, the moon is a symbol of the female principle, which is active in both genders; it stands for the unconscious, intuitive, emotional and subjective.

The title of the picture *The Moon-Woman Cuts the Circle* is however, according to Michael Leja, difficult to interpret by reference to Jung's writings. "Perhaps she cuts the circle of the full moon to produce the crescent, or she may so appear in her character as Opener of the Womb, or as the deity to whom circumcisions were dedicated." All the same, Leja sees Pollock's use of Jungian symbolism not as an unconscious, but rather as a deliberate act in a social context which, since the late 1930s, had turned away from political and sociological models to explain crisis situations, and increasingly preferred the approach of psychological theories.

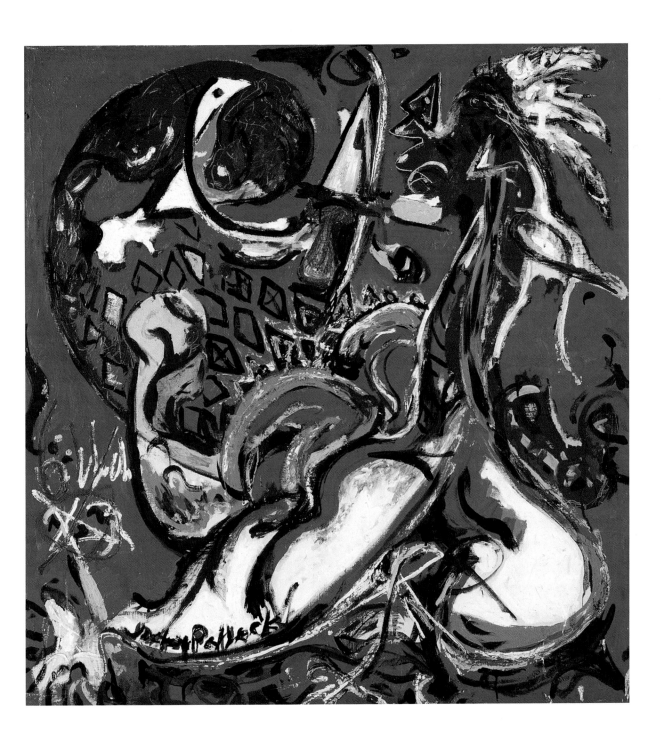

water of the Flowery Mill

Oil on canvas, 107.32 x 122.67 cm
New York, Metropolitan Museum of Art, George A. Hearn Fund, 1956

**b. 1904 in Khorkom (Armenia),
d. 1948 in Sherman (USA)**

Thomas M. Messer waxed eloquent in 1981 on the occasion of an Arshile Gorky retrospective at the New York Guggenheim Museum, stressing his key artistic position at the interface between Surrealism and Abstract Expressionism: "Arshile Gorky, seen as the end product of a historical evolution, becomes the last link in a chain of modern painters who have compelled our vision since the late nineteenth century. But at the same time and not inconsistent with such a view, we endow Gorky today with the attributes of a pioneer. For it was his painterly insights and attributes that helped shape the generation of Americans who, having waged their first decisive battles at about the time of his death, were carried to prominence and victory in the 1950s as the martyrs or heroes of the New York School."

Messer's rhetoric would doubtless have assigned Gorky, who hanged himself in his studio in 1948, to the camp of martyrs. Born in Armenia as Vosdanik Adoian, he emigrated to the USA with his sister in 1920 as a consequence of the Turkish government's policy of persecution and expulsion. In the spring of 1924 he painted his first picture, which he signed with the pseudonym Arshile Gorky; the forename alluded to the great hero of Ancient Greece, Achilles, and the surname to the Russian writer Maxim Gorki. A few months later, Adoian alias Gorky moved to New York – the same year as André Breton's first Surrealist Manifesto appeared in Paris. In 1944 he met Breton and became friends with other émigré Surrealists.

Gorky worked in the late 1920s at first under the influence of the Synthetic Cubism of Georges Braque and Pablo Picasso, in the 1930s he oriented himself in his figurative work towards Picasso's neo-classical figures of the 1920s. But from the middle of the decade Gorky's own artistic development came to be dominated by Surreal-

ism, in particular the works of André Masson and Joan Miró. "… art," he commented in 1945 on his intensive confrontation with modern trends, "is a language that must be mastered before it can be conveyed."

Likewise in 1945 Gorky presented the first of his solo exhibitions at the Julien Levy Gallery in New York, which continued to exhibit his work regularly right up to his death (his first solo exhibition of all was at the Mellon Galleries in Philadelphia in 1931, his first in New York at the Boyer Galleries in 1938); from now on, Gorky was able for the first time in his career to lead a life free of financial worries. For the catalogue, Breton wrote a contribution entitled "The Eye-Spring", in which he emphasized both Gorky's closeness to Surrealism and the fact that his method of presenting pictures deviated from that of the Surrealists.

While the latter put their trust in "psychological automatism" as an artistic process, Gorky, in pictures like *Water of the Flowery Mill* started out from the observation of nature. In summer 1942 he had begun, as he said, to "look into the grass" on his parents-in-law's farm in Virginia, sketching, from nature, the forms and movements of plants and insects in the summer heat. "Here for the first time nature is treated as cryptogram," remarked Breton in "The Eye-Spring": from the link between memories and associations, studies of nature and other forms, which Gorky obtained from art, not least from traditional Armenian culture, he created "hybrids", which allowed him "to decode nature to reveal the very rhythm of life".

Bacchanale

Oil on cardboard, 162.6 x 121.9 cm
Private collection

**b. 1880 in Weissenburg (Germany),
d. 1966 in New York (USA)**

"I would maintain," wrote Clement Greenberg in 1961 about Hans Hofmann, "that the only way to begin placing Hofmann's art is by taking cognizance of the uniqueness of his life's course, which has cut across as many art movements as national boundaries, and put him in several different centers of art at the precise time of their most fruitful activity. On top of that, his career as an artist has cut across at least three artists' generations."

Hofmann had attended a private art school in Munich from 1898. Between 1904 and the outbreak of the Great War in 1914 – the period which saw the appearance of Fauvism and Cubism – he lived in Paris; like Henri Matisse, one of the places he studied at was the Académie de la Grande Chaumière, and he was friendly with artists such as Sonia and Robert Delaunay. Exempted on medical grounds from military service, in 1915 he opened an art school in Munich, where one of the students was the future head of the art department at the University of California in Berkeley, Worth Ryder.

At Ryder's invitation, Hofmann paid his first visit to the USA in 1930, and moved there permanently in 1932. He taught at the Art Students League in New York, among other places, and the following year opened an art school of his own in the city. Its numerous prominent alumni included Ray Eames, Allan Kaprow and Lee Krasner. The latter introduced him to her husband Jackson Pollock in 1942, and it was due to Pollock's mediation that Hofmann was able to hold his first New York solo exhibition at Peggy Guggenheim's influential Art of This Century gallery in 1944.

In Hofmann's pictures dating from this period, which include alongside *Bacchanale* also *Idolatress I* (1944) and *Ecstasy* (1947), we find dionysiac motifs, transcending the rational, which come close to abstraction. In a 1948 article, "The Search for the Real in the Visual Arts", Hofmann explained his conviction that painting and sculpture were an expression of the surreal in material form. In his exuberant, gestural painting technique, Hofmann squeezed some of the paint directly from the tube on to the canvas; "The weight and density of his paint," in Greenberg's view; "launched the 'heavy' surface in abstract art," both visually and physically.

Hofmann occupies a particular role in Abstract Expressionism not only by reason of belonging to an older generation, but also because he was the first painter of the New York School to be identified by this description. The critic Robert Coates reviewed Hofmann's comprehensive solo exhibition at the Mortimer Brandt Gallery for "New Yorker" in 1946 and spoke here for the first time of a current artistic trend which he christened "Abstract Expressionism".

In addition, Coates commented on the squirts of paint in Hofmann's pictures, in a sense a prototype of Jackson Pollock's dripping technique, which was developed in 1947.

"There's no doubt," observed Coates in respect of Hofmann's exhibition, and not without a hint of smugness, "that his painting is 'difficult', and there are four or five of the eighteen canvases in the show in which the emphasis on accidental effects (that is, spatters and daubs) is so strong that I'd be willing to dismiss them as sheer nonsense if in some of the others he didn't display a combination of subtlety and power which argues an over-all intention too well developed to be brushed aside so lightly."

HOW to LOOK at MODERN ART in AMERICA

Cartoon
For the magazine "PM", 2 June 1946

**b. 1913 in Buffalo,
d. 1967 in New York (USA)**

The chronology which Ad Reinhardt compiled for his retrospective in the New York Jewish Museum in 1966 combines personal, political and art-historical information with double-edged observations. It reads like an experimental autobiography: "1913 Born, New York, Christmas Eve, nine months after Armory Show. (Father leaves 'old country' for America in 1907 after serving in Tsar Nicholas' army. Mother leaves Germany in 1909.)" Even this very first entry relating to the year of the artist's birth resembles the opening paragraph of a novel. Reinhardt describes himself in a sense as a "child" of the Armory Show, that legendary major exhibition of modern art which in 1913 first acquainted the American public with post-Impressionist avant-garde art; in addition, by noting that he was born on Christmas Eve, Reinhardt confers on his self-presentation a tongue-in-cheek messianic undertone. And finally the year of his birth also seems to anticipate his artistic programme: "1913 Malevich paints first geometric-abstract painting."

In fact, the composing of texts and the production of pictures are inseparable in Reinhardt's artistic practice. While he saw the strict division of art and life as fundamental to his painting, in his highly allusive "Art Comics" he subjected the intricacies of the post-1945 booming New York art market to mercilessly ironic criticism. Most of these cartoons, which were created between 1945 and 1956, first appeared in the left-liberal, anti-fascist and anti-communist magazine "PM" and later in "ArtNews"; the aesthetic techniques used are free-hand drawings and collages, for which latter Reinhardt often used illustrations from nineteenth-century books and magazines.

The early cartoon *How to Look at Modern Art in America*, dating from 1946, was described by Reinhardt in the accompanying text as a "gallery guide – the art-world in a nutshell". He gave visual metaphorical expression – in the form of a tree in a field of maize – to a spectrum of painting which from Reinhardt's point of view ranged from "pure (abstract) 'paintings'" on the left-hand side to "pure (illustrative) 'pictures'" on the right-hand side. The leaves stand for the individual artists – a few empty pages can be filled and inserted in by readers themselves; the trunk and roots represent their historical precursors. In the accompanying text, Reinhardt writes that the most inaccessible artists are to be found on the left-hand side, the easiest and most familiar on the right; at the same time he criticizes artists like Philip Guston, "who somehow regard themselves as abstract and illustrative at the same time (as though one could be both nowadays)".

Fifteen years later, in the summer of 1961, Reinhardt published an updated version of the cartoon in "ArtNews", in which many names appeared in new positions. Reinhardt was drawing a picture of decline: the whole left-hand half of the tree, including the branch representing "pure (abstract) 'painting'", has gone, while the most overloaded branch, with the names of artists whose pictures Reinhardt saw as "pure (illustrative)", continues to hang down heavily towards the ground. Reinhardt's laconic solution approach remains unchanged: "The best way to escape from all this is to paint yourself."

> **"It's been said many times in world-art writing that one can find some of painting's meanings by looking not only at what painters do but at what they refuse to do."**
>
> **Ad Reinhardt**

HOW TO LOOK AT MODERN ART IN AMERICA

by Ad Reinhardt

Here's a guide to the galleries—the art world in a nutshell—a tree of contemporary art from pure (abstract) "paintings" (on your left) to pure (illustrative) "pictures" (down on your right). If you know what you like but don't know anything about art, you'll find the artists on the left hardest to understand, and the names on the right easiest and most familiar (famous). You can start in the cornfields, where no demand is made on you and work your way up and around. Be especially careful of those curious schools situated on that overloaded section of the tree, which somehow think of themselves as being both abstract and pictorial (as if they could be both today). The best way to escape from all this is to paint yourself. If you have any friends that we overlooked, here are some extra leaves. Fill in and paste up...

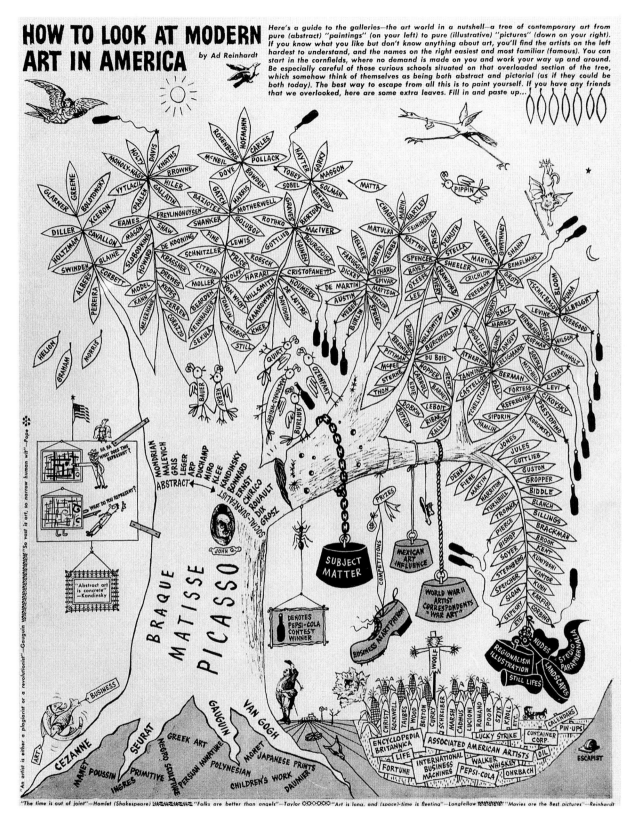

"The time is out of joint"—Hamlet (Shakespeare) "Folks are better than angels"—Taylor "Art is long, and (space)-time is fleeting"—Longfellow "Movies are the Best pictures"—Reinhardt

33

cyclops

Oil on canvas, 121.9 x 101.6 cm

Chicago, The Art Institute of Chicago, Walter M. Campana Memorial Prize Fund

**b. 1912 in Pittsburgh,
d. 1963 in New York (USA)**

"Today it's possible to paint one canvas with the calmness of an ancient Greek, and the next with the anxiety of a Van Gogh," wrote William Baziotes in 1947. This makes him seem almost like a post-modernist artist, open to all kinds of influences without respect to period. Thus indirectly he also rejected ideas – frequently associated with modern art – concerning the "originality" and "uniqueness" of the artist, when, in 1954, he observed: "The painter who imagines himself a Robinson Crusoe is either a primitive or a fool." Baziotes was born the son of Greek immigrants and grew up in poor circumstances; from 1933 to 1936 he studied at the National Academy of Design in New York and subsequently worked until the early 1940s for the Works Progress Administration, a state-sponsored art-promotion programme whose socially committed orientation was, however, alien to him.

In 1941 Baziotes became friends with Robert Motherwell, whose interest in French Symbolism and Surrealism he shared; thus we can find in Baziotes' pictures coloration and motifs inspired by the poetry of Charles Baudelaire. Contacts with Surrealist exiles in New York, but in particular his friendship with the Chilean painter Roberto Matta, helped Baziotes to develop his own personal version of "écriture automatique", which the art historian Lawrence Alloway hit the nail on the head by describing as "slow automatism". At the same time, figurative hints are never absent from his pictures, conjuring up ideas of mysterious, archaic organisms; in contrast to most of the other painters regarded as Abstract Expressionists, large formats and the forcing of the gestural play no role in his painting.

"The emphasis on flora, fauna and beings makes the exhibit a most intriguing and artistic one for it brings forth those strange memories and psychic feelings that mystify and fascinate all of us," remarked Baziotes in 1957. An interest in "primitive" cultures and the processes of the unconscious, as was to be expressed in artistic techniques like the écriture automatique of Surrealism, was widespread in the culture of 1940s' America. Thus there was a trend to search for parallels between early cultural witnesses – for example, classical mythology – and contemporary consciousness, which was perceived as desperate and tragic. Arguments for this view could be found for example in the writings of Sigmund Freud and C. G. Jung, translations of which were avidly devoured in the USA during the 1940s.

Baziotes often went beyond Surrealism to older traditions of fantastic art. For example, the eponymous motif of the painting *Cyclops* points among other things to the work of the French Symbolist Odilon Redon (1840–1916), in whose pictures the motif of one-eyed figures is not infrequent; Baziotes was also inspired by a visit to the Bronx zoo, where he observed a rhinoceros, for him a descendant of some primeval race. According to Greek mythology, the cyclopes were one-eyed giants who could summon up thunder and lightning, and so we can also see in Baziotes' interest in this figure an autobiographical aspect – a reference to his own Greek heritage.

"ı kept … returning to the [ancient ʀᴏᴍᴀɴ] wall paintings with their veiled melancholy and elegant plasticity."

William Baziotes

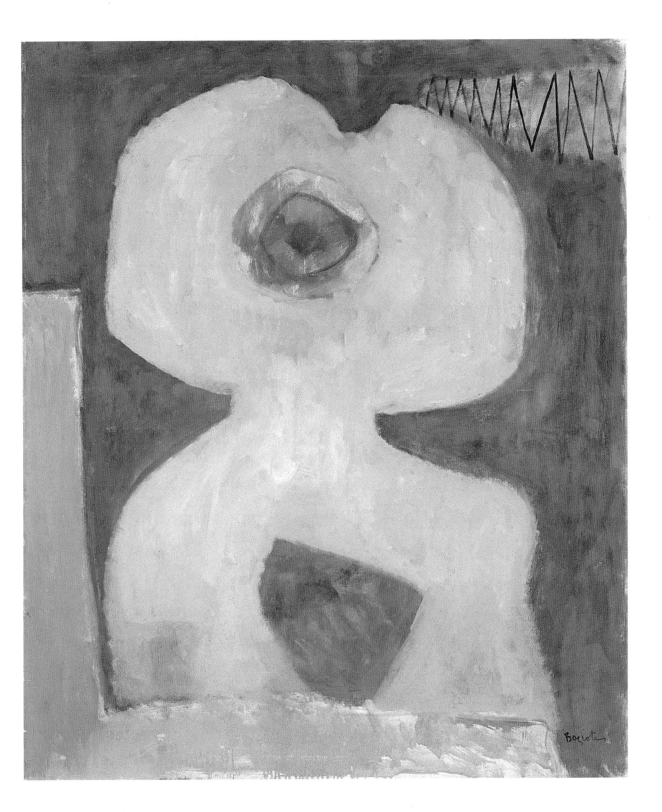

Full Fathom Five

Oil on canvas, nails, drawing-pins, buttons, keys, coins, cigarettes, matches etc., 129.2 x 76.5 cm
New York, The Museum of Modern Art, Gift of Peggy Guggenheim

The winter of 1946–47 marks a decisive change in the work of Jackson Pollock: a turning away fro traditional easel-painting and the start of his work on large-format canvases spread out on the floor. Pollock had come across the dripping technique in 1936 at the "Experimental Workshop" of the Mexican painter David Alfaro Siqueiros (1896–1974), also described as "a laboratory of modern techniques in art", and he had already applied it in 1943 in *Composition with Pouring II*. It is true that Hans Hofmann and Surrealists like André Masson and Max Ernst had already experimented with this form of paint application before Pollock, but "it was not the dripping, pouring or spattering *per se*, but what Pollock *did* with them that counted," as William Rubin observed in 1967.

In a statement for the magazine "Possibilities", whose one and only edition came out in the winter of 1947–48, Pollock described his painting process in detail: "My painting does not come from the easel. I hardly ever stretch my canvas before painting. I prefer to tack the unstretched canvas to the hard wall or the floor. I need the resistance of a hard surface. On the floor I am more at ease. I feel nearer, more a part of the painting, since this way I can walk around it, work from the four sides and literally be *in* the painting. This is akin to the method of the Indian sand painters of the West." Instead of the ordinary tools of the painter's trade, such as easel, palette and brush, Pollock's techniques of dripping and pouring used objects such as sticks, spatulas, knives, or vessels with which the paint could be dripped or hurled on to the canvas, without directly touching the latter; sometimes the paint was mixed with other materials such as sand or splinters of glass.

While the interest of today's interpreters is now more strongly oriented towards the share of conscious control of the painting process, Pollock emphasized the automatism of his approach, which points to the influence of the Surrealist "dessin automatique": "When I am in my painting, I'm not aware of what I 'm doing. It is only after a sort of 'get acquainted' period that I see what I have been about. I have no fears about making changes, destroying the image, etc., because the painting has a life of its own. I try to let it come through. It is only when I lose contact with the painting that the result is a mess. Otherwise there is pure harmony, an easy give and take, and the painting comes out well."

As was revealed by an X-ray examination carried out by the Museum of Modern Art's restoration workshop in the late 1990s, the weave of the top colour-layers in *Full Fathom Five* veils a figure in lead paint. The objects worked into the picture, such as keys or buttons, are placed with reference to this hidden figure, as could be demonstrated by the X-ray pictures.

The title *Full Fathom Five* was suggested by the writer Ralph Mannheim: it is a line from a song in Shakespeare's "The Tempest", and here it alludes to the figure "submerged" beneath the smears of paint: "Full fathom five thy father lies/Of his bones are coral made/Those are pearls that were his eyes/Nothing of him that doth fade/But doth suffer a sea-change/Into something rich and strange."

"Abstract painting is abstract. It confronts you. There was a reviewer a while back who wrote that my pictures didn't have any beginning or any end. He didn't mean it as a compliment, but it was. It was a fine compliment…"

Jackson Pollock

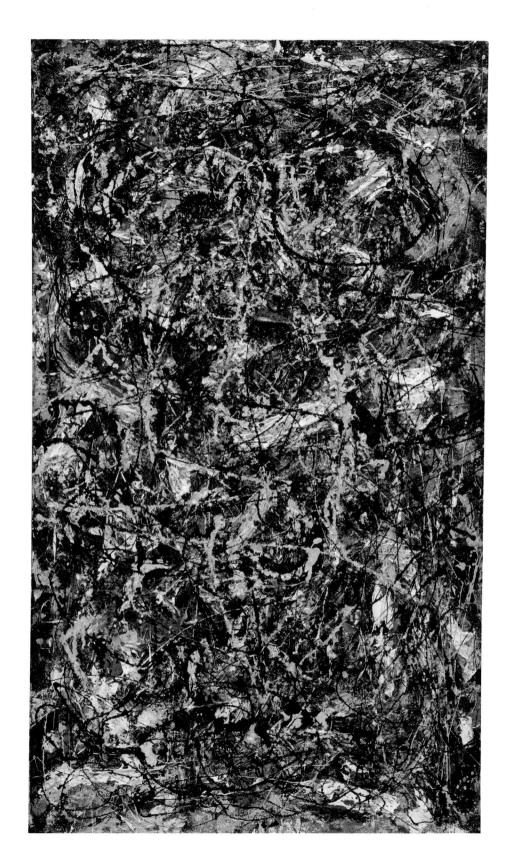

ᴛне ᴛoᴙmentors

Oil on canvas, 103.84 x 153.67 cm
San Francisco, San Francisco Museum of Modern Art, Gift of the artist

**b. 1913 in Montreal (Canada),
d. 1980 in Woodstock (USA)**

Philip Guston grew up in Montreal and Los Angeles as the child of Russian immigrants from Odessa. Even as a teenager he started to draw cartoons, and enrolled in a correspondence course at the Cleveland School of Cartooning. As a student during the 1930s, Guston took an interest in, among other things, Giorgio de Chirico's Pittura metafisica and its older historical precursors, including the frescoes of Italian Renaissance artists such as Masaccio, Andrea Mantegna and Paolo Uccello. In the late 1930s, Guston himself was painting murals for the state-sponsored art-promotion project known as the Works Progress Administration: it was a medium which he hoped would create a broader public for his politically committed figurative painting. In the early 1940s, he returned to easel painting.

It is characteristic of Guston's works that they are often linked by a family-tree; many pictures were developed from elements contained in earlier works. "To paint is always to start at the beginning again, yet being unable to avoid the familiar arguments about what you see yourself painting. The canvas you are working on modifies the previous ones in an unending, baffling chain which never seems to finish," was how he described his working method in the magazine "ArtNews" in 1966.

The Tormentors, considered to be Guston's first abstract picture, was painted at a time when most of the artists regarded as Abstract Expressionists were giving up the figurative elements in their painting. The composition of *The Tormentors* takes up motifs from an earlier, still figurative work, *Porch No. 2* (1947), a picture which also reveals Guston's confrontation with the Expressionist painting of Max Beckmann (1884–1950); both artists worked for a time under the influence of world war: the First in Beckmann's case, the Second in Guston's. Among the important impulses for Guston's pictures in the immediate post-war period are thought to be the photographs taken by Margaret Bourke-White during the liberation of concentration-camp prisoners from Buchenwald; these pictures appeared in "Life Magazine" in May 1945.

Porch No. 2 shows, in a kind of theatrical setting, a row of children on a stage-like veranda: Disjointed body-parts and a headless body suspended as if by its feet evoke ideas of violence. In *The Tormentors* the figurative allusions are much less in evidence, but the title points to a traumatic situation. Guston insisted on the narrative aspect of his painting, even while his work tended towards the abstract during the 1940s and 50s. At a panel discussion in 1960, a time when new figurative art movements such as Nouveau Réalisme and Pop Art were about to make their breakthrough, he said: "There is something ridiculous and miserly in the myth we inherit from abstract art: That painting is autonomous, pure and for itself, therefore we habitually analyse its ingredients and define its limits. But painting is 'impure'. It is the adjustment of 'impurities' which forces its continuity. We are image-makers and image-ridden."

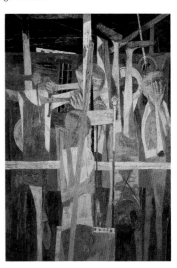

Porch No. 2, 1947

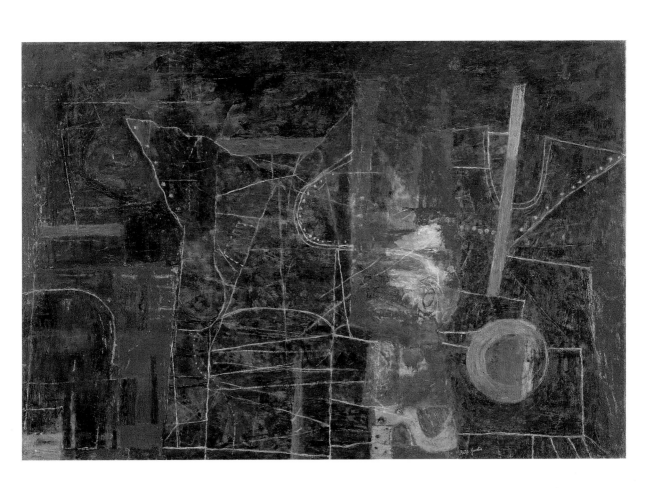

onement ı

Oil on canvas, 69.2 x 41.2 cm
New York, The Museum of Modern Art, Gift of Annalee Newman

**b. 1905 in New York,
d. 1970 in New York (USA)**

In April 1945 Barnett Newman wrote in an article on Rufino Tamayo and Adolph Gottlieb: "Man is a tragic being, and the heart of this tragedy is the metaphysical problem of part and whole. This dichotomy of our nature, from which we can never escape and which because of its nature impels us helplessly to try to resolve it, motivates our struggle for perfection and seals our inevitable doom. For man is one, he is single, he is alone; and yet he belongs, he is part of an other. This conflict is the greatest of our tragedies…" In the New York art world, Newman was, until well into the 1950s, known above all to many contemporaries as a curator and (often polemical) author. Thus in 1944 and 1946 he had organized exhibitions of pre-Columbian painting for the Betty Parsons Gallery. In these projects, as also in his earlier writings, Newman indicated his interest in "primitive" art – to which his own art was supposed to be the modern equivalent – as the expression of the human search for metaphysical insight.

The birth of *Onement I* was dated by the artist to 20 January 1948, his own 43rd birthday. A rectangular canvas in vertical format, with a partly translucent application of russet paint, is divided down the middle by a narrow orange-red strip, or stripe, of painted adhesive tape with irregular edges. The vertical stripe Newman called a "zip" and indeed, it does both divide and re-unite the two halves of the picture like a zip-fastener. For Newman it was "a field that brings life to the other fields, just as the other fields bring life to this so-called line."

The first zips had already appeared in 1946 in a number of pictures such as *Moment* or *Genesis – The Break*. Even so, *Onement I* is regarded as a decisive turning-point in Newman's artistic development. In 1965, he described it as the new beginning of his existence: "I realized that I'd made a statement which was affecting me and which was, I suppose, the beginning of my present life, because from then on I had to give up any relation to nature, as seen." In fact Newman referred to *Onement I* having, in his view, a kind of independent existence: "The painting itself had a life of its own in a way that I don't think the others did, as much."

The importance of this image-creation can be seen not least in the fact that *Onement I* was followed by about a year of unusual productivity, in which seventeen other works appeared. Thus in *Onement III* (1949) Newman used the same compositional principle as in *Onement I*, while increasing the dimensions of the picture to 182.5 x 84.9 cm, so that it could be viewed by beholders even more strongly as something with which they were physically confronted. To this extent, *Onement I* and the invention of the zip can be understood as the painterly expression of what Newman already in 1945 was calling the "metaphysical problem of part and whole". And indeed, when one views Newman's compositions from close up, as the artist demanded on the occasion of his second exhibition at the Betty Parsons Gallery in 1951, "man is one, he is single, he is alone; and yet he belongs, he is part of an other."

"what is the explanation
of the seemingly insane drive
of man to be painter and
poet if it is not an act of defiance
against man's fall and
an assertion that he return to
the ᴀdam of the ɢarden of ᴇden?
ꜰor the artists are the first men."

Barnett Newman

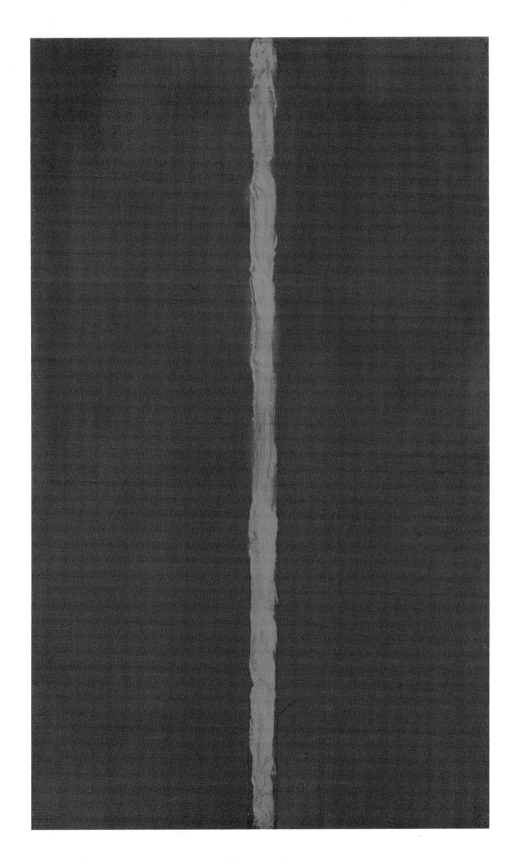

untitled

from the "Multiforms" series, 1946–1949, oil on canvas, 127.6 x 109.9 cm
Private collection, Kate Rothko-Prizel collection

**b. 1903 in Dvinsk (Russia),
d. 1970 in New York (USA)**

"One might say that Rothko and his friends constituted the theological sector of Abstract Expressionism," observed Harold Rosenberg two years after Rothko's death in 1970. "Together with Still, Newman, Reinhardt, Gottlieb (the names suddenly translate themselves into characters of a miracle play), Rothko sought to arrive at an ultimate sign."

Indeed, Mark Rothko had given expression to his religious attitude in numerous articles, for example in a statement in 1945 on the occasion of his participation in the group exhibition "A Painting Prophecy", he stressed his belief that alongside everyday reality there existed both a world generated in human consciousness as well as one created by God outside human consciousness.

Marcus Rothkowitz, who abbreviated his name to Mark Rothko in 1940, emigrated with his family to the USA in 1913 on account of the political and economic pressure being applied to Russian Jews. He lived in America thereafter, moving in 1923 from Portland, Oregon, to New York, where he enrolled at art college. In the 1920s and 1930s, he worked in a figurative style, which sometimes recalls the Italian Pittura metafisica: among his 1930s' cityscapes there are numerous street and subway scenes reflecting the isolation of big-city existence. In the early 1940s, Rothko, influenced by Surrealism, largely painted mythological motifs.

In about 1946 he began to put this style behind him and to develop an abstract formal language of his own from colour fields which come across as partly transparent or floating in an atmospheric pictorial space, such as *Untitled*, dating from 1948. The large-format works of the period 1946 to 1949, which Rothko saw as a transition to his later working technique, are often described as "multiforms", a term not coined by Rothko himself. The artist saw his pictures as the living "counterpart" of the beholder, which could be hurt by the latter's ignorance. Thus in 1947 he wrote in "The Romantics Were Prompted": "On shapes: They are unique elements in a unique situation. They are organisms with volition and a passion for self-assertion. They move with internal freedom, and without need to conform with or to violate what is probable in the familiar world. They have no direct association with any particular visible experience, but in them one recognizes the principle and passion of organisms."

The art historian Eliza E. Rathbone emphasized, tellingly, that Rothko's work possessed "an aspect of self-portraiture", which makes his pronounced desire to exercise as much control as possible over the reception of his pictures all the more plausible. Thus in March 1948, in a letter to his long-standing dealer Betty Parsons, he wrote that his pictures should not be accessible to every visitor, but only to those who understood something of their value. In particular, no one was to be allowed to write about them. These were demands that, with Rothko's increasing success from the mid-1950s, due not least to his new dealer Sidney Janis, were hardly enforceable.

> "A picture lives by companionship, expanding and quickening in the eyes of the sensitive observer. It dies by the same token. It is therefore a risky and unfeeling act to send it out into the world. How often it must be permanently impaired by the eyes of the vulgar and the cruelty of the impotent who would extend the affliction universally!"
>
> **Mark Rothko**

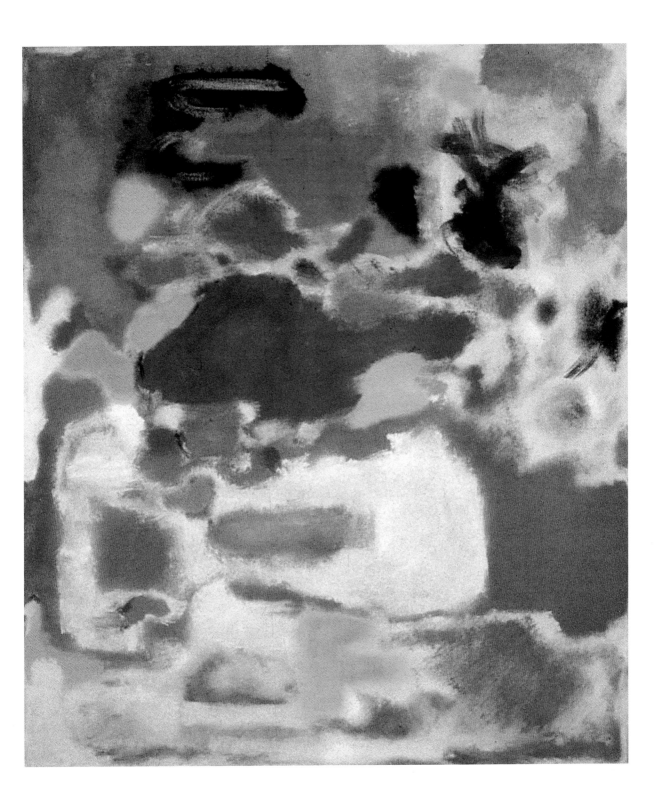

untitled

from the series "Little Images", 1946–1950, oil on composition board, 121.9 x 94 cm
New York, The Museum of Modern Art, Gift of Alfonso A. Ossorio

b. 1908 in New York,
d. 1984 in New York (USA)

Of all the Abstract Expressionist artist-couples, the private and professional partnership between Lee Krasner and Jackson Pollock is doubtless the best-known and most investigated. This widely-practised approach to Krasner's work – only seeing it in relation to Pollock's – is in itself enough to point up her dilemma as an artist: her difficulty consisted largely in being taken notice of without her work being reduced on the one hand to her being a woman, or on the other to her relationship with Pollock, the leading figure of Abstract Expressionism. This was less an individual than a historically conditioned situation, which Krasner shared with other female artists in the field of Abstract Expressionism, as the American art historian Michael Leja emphasized in 1993: namely the "exclusion from the experience of and the power to represent the self of Modern Man discourse, as that self was embodied in Abstract Expressionist painting and aesthetics." "Modern Man" in the prevailing view was always male, white and heterosexual.

Lee Krasner, whose real name was Lena Krassner, was the child of Ukrainian immigrants. She started her artistic training in 1929 at the age of 21, and between 1937 and 1940 she took lessons at Hans Hofmann's renowned School of Fine Arts, which familiarized young American artists with the formal achievements of modern European painting. It was here that Krasner began to paint in an abstract style; regular exhibitions followed, for example with the group known as American Abstract Artists.

From the start of her relationship with Pollock, Krasner's work took a back seat to his, both in respect of her own productivity, and of her public presence. The period between 1942 and 1945, during which Krasner and Pollock shared a studio on Eighth Street, she once described as her "black-out period", in which very few works were painted or preserved. Pictures which Krasner called "grey slabs" were constantly being scraped off the canvas and covered with dense new layers of paint, as though the motifs beneath were not to come to the surface.

After the couple settled in The Springs on Long Island in 1946, living a somewhat reclusive life, Krasner painted her first important group of abstract works, entitled *Little Images* (1946–1950), in which she moved on from the Cubist schemes of composition taught by Hofmann, and started to work on the all-over principle. Barbara Rose has divided this group of works into three series: (1) mosaic (divisionist); (2) webbed, 1947–49; and (3) grid (hieroglyph). Krasner herself summarized all these works under the heading "hieroglyphs". Krasner shared an interest in the calligraphic and in the Surrealist "écriture automatique" with artists such as Mark Tobey and Bradley Walker Tomlin.

The fact that in some of the *Little Images* – whose title sounds like a demonstrative, maybe ironic gesture of humility – she used the technique of dripping is mostly interpreted as a reaction to Pollock's current experiments in this technique. However Krasner's dripping, unlike Pollock's, comes across not as an expression of an uninhibited breaking-down of barriers, but as a reaction to the constraints of the grid-structure. This process has often been interpreted negatively as the expression of some sort of mental block or of exaggerated self-control. Krasner herself, by contrast, described it in positive terms, as the attempt at union of opposites such as male and female, organic and geometric, mind and matter.

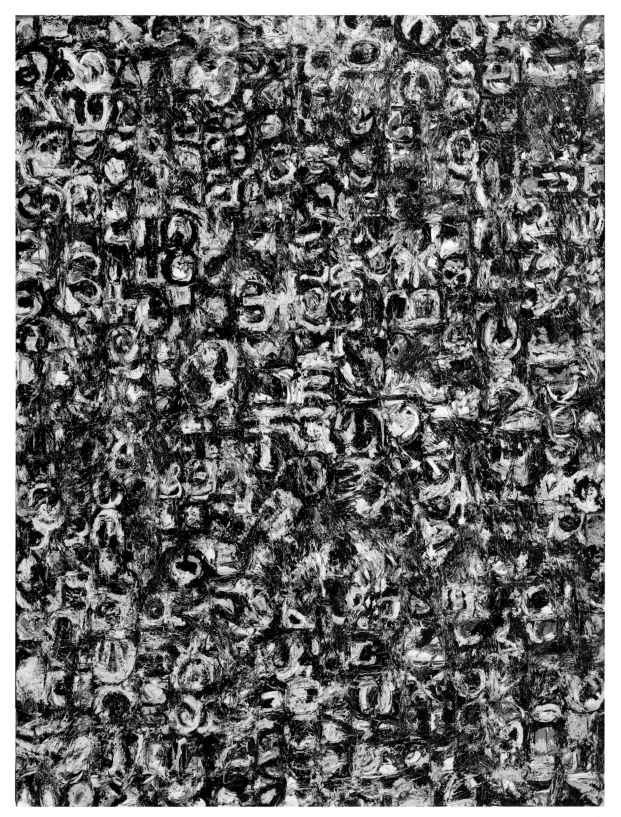

1949-H

Oil on canvas, 203.2 x 175.26 cm
Buffalo, Albright-Knox Art Gallery, Gift of the artist, 1964

**b. 1904 in Grandin,
d. 1980 in New York (USA)**

In 1966 Ethel Moore wrote in the biographical notes for the catalogue of an exhibition by Clyfford Still: "When he was twenty he made the first trip to New York, arriving at the Metropolitan Museum of Art before the doors opened. He was, however, disappointed in what he saw. He found something missing, some statement that he felt profoundly and did not find in the work of the European masters. Having decided that he should pursue a more formal art education, he enrolled in a class at the Art Students League but found that disappointing also, and left after 45 minutes." Still remained in the city – this was in 1924 – for a few more weeks, in order to visit more museums and galleries, but the first impression seemed only to be confirmed. "Disillusioned, he shortened his stay in New York and returned West."

These few sentences sketch out the picture of the eccentric American artist in an almost idealizing fashion. His "disillusionment" with and rejection of European art, which he saw as "decadent", the fact of his being self-taught, his distancing himself from the big city – New York – and its "corrupt" art scene, and finally his departure and return to the American West. In 1945, twenty years after his early "disappointment", Still returned however to New York and was living there – with interruptions – during the period of the "triumph of American painting", as Irving Sandler put it. In the mid-1950s, while he refused to take part in exhibitions in New York, this gesture of withdrawal was rewarded by the public, who interpreted it as a sign of his particular artistic authenticity, and it certainly did nothing to diminish his renown. In 1961 Still finally retired to the rural isolation of Maryland.

During the final years of the war, Still had concerned himself, like many of his fellow artists, with myth-laden motifs, but in 1946–47 he developed his characteristic form of colour-field abstraction, with mostly vertically oriented forms and abrupt, irregular contours, as seen in *1949-H*. The oil-paint, applied to the canvas with a spatula, comes across as cracked and intentionally "uncultivated". Within the colour zones there is no shading, and between them there are no figure-to-ground relationships. Still's all-over compositions come across as details of a larger field extending beyond the borders of the picture, which in turn contributes to the unfinished appearance of the picture.

Interpreters of Still's pictures have seen in them time and again references to the wide-open landscape of North Dakota where he was brought up, or to the American west coast, where he lived and taught in the late 1940s. This brings the aesthetic concept of the "sublime" into play, which was also central for other artists such as Barnett Newman and Mark Rothko: the confrontation of the subject with the idea of infinite size or infinite power in the face of an overwhelming experience (of nature). Still himself promoted this view of things, for example when he wrote in 1963: "The sublime? A paramount consideration in my studies and work from my earliest student days. In essence it is most elusive of capture or definition – only surely found least in the lives and works of those who babble of it the most."

"Demands for communication are both presumptuous and irrelevant. The observer usually will see what his fears and hopes and learning teach him to see."

Clyfford Still

all souls' night, no. 2

Oil on canvas, 121.9 x 81.3 cm
Washington, D. C., Private collection

===

**b. 1899 in Syracuse,
d. 1953 in New York (USA)**

The critic John Ashbery once described Bradley Walker Tomlin as "the gentleman Abstract Expressionist" – a double-edged compliment, which did its subject no favours. In a context that defined masculinity rather in terms of extroversion, aggressiveness and competitiveness, Tomlin found himself in the role of outsider.

Like most of the artists of the New York School of this generation, Tomlin had first worked in a figurative style before turning to abstraction, in his case not until 1946. From then on, he was one of the regular artists exhibiting at the Betty Parsons Gallery, which at the time represented the majority of exponents of Abstract Expressionism. In the fall of 1949, Tomlin took part in the group exhibition entitled "The Intrasubjectives", by which the Samuel Kootz Gallery hoped to establish a kind of canon of Abstract Expressionism. In addition to a painting by Tomlin, works by William Baziotes, Willem de Kooning, Arshile Gorky, Adolph Gottlieb, Hans Hofmann, Robert Motherwell, Jackson Pollock, Ad Reinhardt, Mark Rothko and Mark Tobey were displayed.

Kootz used the title "The Intrasubjectives" to suggest that the stylistically different artists gathered there did not orient themselves by the external world when making their pictures, but primarily from the exploration of their inward selves. Tomlin's lyrical *All Souls' Night, No. 2* seems to be entirely in accord with this idea. The title of the picture refers to the Christian festival that takes place on 2 November and thus alludes also to the idea that unredeemed souls return to earth on this night in order to recuperate from the torments of Purgatory.

Tomlin, like many of his fellow artists, was interested in oriental calligraphy and in Surrealist "écriture automatique" as a means of access to the unconscious; unlike Pollock's contemporary drip-paintings or Franz Kline's vehement, beam-like brush-strokes, Tomlin's application of paint comes across, however, as more calculated and recalls the work of Paul Klee.

The voices of the prominent authors who wrote about his work are conspicuously of one mind: thus Thomas B. Hess, on the occasion of Tomlin's first solo exhibition at the Betty Parsons Gallery in 1950: "Here and there are lapses of taste – or, more serious, too great an emphasis on 'good taste'." Philip Guston, who was friends with Tomlin, noted in respect of the latter's posthumous retrospective in 1957, that Tomlin's "temperament insisted on the impossible pleasure of controlling and being free at the same moment". And Dore Ashton commented the same year on his version of the all-over, that by the late 1940s was part of the common artistic stock-in-trade of the New York School: "He used it intelligently, but too intelligently."

Tomlin, like many of his fellow artists, attempted to intervene in the debate about his work. Thus in reaction to a review of his last solo exhibition at the Betty Parsons Gallery in 1953, a review in which he regarded himself as having been inappropriately interpreted, he wrote to the magazine "ArtNews": "Frankly, at times, I think the art critics have something to do with it… that they stymie things – what with all these different promotions about who is the great American painter, how can they ever get results?"

The fact that Tomlin is one of those Abstract Expressionist artists whose work was less highly regarded in their lifetimes, and is threatened today with oblivion, can also be understood as an effect of art criticism, a fact that Tomlin himself was only too well aware of. The crucial influence of critics on artistic careers was more than clear in the case of Pollock and Clement Greenberg or de Kooning and Harold Rosenberg.

Excavation

Oil and gloss-paint on canvas, 206.2 x 257.3 cm
Chicago, The Art Institute of Chicago, Mr. and Mrs. Frank G. Logan Purchase Prize Fund,
Gift of Mr. Edgar Kaufman, Jr., and Mr. and Mrs. Noah Goldowsky

b. 1904 in Rotterdam (Netherlands),
d. 1997 in New York (USA)

"De Kooning's is a slippery universe made of expanding numbers of indications and changing points of view," observed Thomas B. Hess in the first monograph about the artist, which appeared in 1959. The number of "allusions and changing standpoints" that Hess observed in Willem de Kooning points not least to the legacy of Cubism, which de Kooning confronted in numerous works. In a lecture on abstract art at the New York Museum of Modern Art in 1951, where *Excavation* was currently on display, he emphasized: "Of all movements, I liked Cubism most."

Born in the Netherlands, de Kooning obtained an artistic training at, among other places, the Rotterdam Academy of Art and Technology and in 1926, at the age of 22, went to New York; where, from 1936, he devoted himself exclusively to painting. In spite of an obvious concern with the Cubists and the work of Pablo Picasso, he described himself in an interview with Harold Rosenberg in 1972 as "an eclectic painter by chance; I can open almost any book of reproductions and find a painting I could be influenced by." The reference system in which *Excavation* can be located is correspondingly many-layered. Apart from a stage-set dating from 1946, it is de Kooning's largest picture. The format and the broken off-white coloration make it look like a wall, which, as it were with graffiti, is covered with a tangled weave of black-contoured, fragmented depictions of bodies. And in fact in the mid-1930s de Kooning had indeed gathered experience in the sphere of mural painting in the framework of the state arts-sponsorship project, the Works Progress Administration.

The sketchily reduced wide-open eyes and mouths are reminiscent of a tumult or a struggle. As one possible input to *Excavation*, Picasso's famous 1937 anti-war picture *Guernica* is often quoted, but another is a spectacular scene from Giuseppe de Santis' 1949 neo-realist black-and-white film "Riso amaro" (Bitter Rice), in which a group of women fight with each other in a rice-field. In addition, de Kooning obtained his inspirations for motifs and coloration often from the everyday world: the construction pit alluded to in the title was a common sight in New York. *Excavation* awakens the impression that it is a pre-existent picture, a historic find, a witness to some human catastrophe, and all that the artist has done is to uncover it. Many exponents of Abstract Expressionism interested themselves, as a result of devastating experiences in the Second World War, in so-called "primitive" art, such as prehistoric cave-painting: de Kooning's title suggests such a retrospective reference.

De Kooning ended his work on *Excavation* in June 1950, when the picture was due to be presented at the American Pavilion at the Venice Biennale – his first important participation at an exhibition abroad. In November 1951 he was awarded the Purchase Prize of the Art Institute of Chicago. *Excavation* did not just mark a moment of institutional recognition in de Kooning's career, however, but at the same time a turning-point in his artistic development: immediately after the work on *Excavation* was finished, de Kooning started on the figurative series *Women*, which was to occupy him until March 1953.

**"I am an eclectic artist by chance;
I can open almost any book
of reproductions and find a painting
I could be influenced by."**

Willem de Kooning

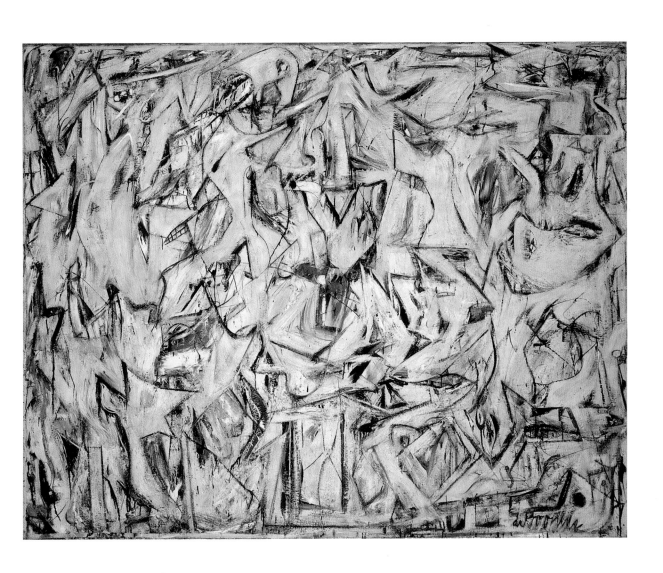

The wild

Oil on canvas, 243 x 4.1 cm
New York, The Museum of Modern Art, Gift of the Kulicke Family, 1969

In about 1950, Barnett Newman began to work on a series of unusual picture formats. At one end of the spectrum there are horizontal pictures more than five metres broad, such as *Vir Heroicus Sublimis* (1950–51) and *Cathedra* (1951), and at the other end, some narrow vertical pictures just a few centimetres across, of which *The Wild* represents an extreme case. On a blue-grey background, a red stripe, about two centimetres across, painted twice over, covers almost the whole picture. Its upper layer is somewhat blurred at the edges. With *The Wild* Newman directed the beholder's attention to the zip, which both divides and unites the monochrome fields of his pictures, making it clear that this was the decisive element in his paintings. According to Thomas B. Hess, Newman was reacting to the opinion of a curator that all that mattered in Newman's pictures were the mutual proportions of the colour fields, placing him in the Bauhaus tradition. In addition, Newman wanted to make it clear that in his

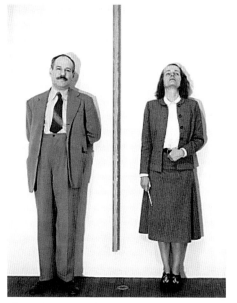

Barnett Newman and Betty Parsons, 1951

painting it was not so much the format as the scale that was important. Thus in 1966 he declared in an interview, with reference to *The Wild*: "I think it holds up as well as any big one I have ever done. The issue is one of scale, and scale is a felt thing."

If Newman, with the isolated zip of *The Wild* was expressly appealing to the feeling for scale – which is bound up with the physical presence of the work and the beholder in the room – this is all the more explicit in his first sculpture, *Here I*, which likewise dates from 1950 and was exhibited together with *The Wild* in 1951 at the artist's one-man show at the Betty Parsons Gallery. Clearly the principle of the isolated zip in *Here I* has been transferred to the third dimension. The sculpture was first executed in plaster-of-Paris; only in 1962 were two copies cast in bronze; it was followed in 1965–66 by the two related sculptures *Here II* and *Here III*. In the case of *Here I* we have a impermanent-looking almost square plinth – a wooden crate for milk-bottles – on which there are two amorphous heaps of plaster, from each of which projects a flat stele, approximately 245 centimetres (ten feet) in height: the narrower of the two has smooth edges, while the broader has ragged edges.

Newman's unusual work, which marks a location, inspired contemporary interpreters to think up a series of symbolic readings, for example with reference to the Jewish religion, or as a metaphor for New York, the city of immigrants and the artistic focus of the Western world. As a possible inspiration for the concept behind *Here I*, an exhibition of stele-like plaster sculptures by Alberto Giacometti often mentioned, which Newman saw at the Pierre Matisse Gallery in New York in 1948.

Also of great importance was his visit to native-American cultic sites in Ohio in 1949, which he regarded as sites of enhanced self-awareness; thus in retrospect he wrote: "Looking at the site you feel, Here I am, *here*… and out beyond there (beyond the limits of the site) there is chaos, nature, rivers, landscapes… But here you get a sense of your own presence… I became involved with the idea of making the viewer present: the idea that 'Man is Present.'"

Number 1, 1950 (Lavender Mist)

Oil, gloss-paint, and aluminium paint on canvas, 221 x 299.7 cm
Washington, D. C., National Gallery of Art, Ailsa Mellon Bruce Fund, 1976

With the creation of more than 50 works, 1950 was the most productive year in Jackson Pollock's career. *Number 1, 1950 (Lavender Mist)*, which appeared in the spring of that year, marks the start of a series of large-format drip-paintings. Together with the three monumental horizontal canvases *Number 32, One: Number 31*, and *Autumn Rhythm: Number 30*, all of which also date from 1950, this is often spoken of as one of Pollock's "classic" works: "They are 'classic' in their thorough use of the pouring application and the uncompromising unity which resulted," as an art-critic observed in the late 1970s. Their radical formal innovation of a non-perspective spatiality, which arose as the result of the layering of hurled or dripped streaks of paint, had the potential to seriously destabilize the position of the beholder. Parker Tyler in his review of March 1950 coined the metaphor of "the infinite labyrinth" – albeit one with no way out, and to which, as Tyler noted, not even its creator seemed to possess the key: a complex structure of numerous labyrinths, one on top of the other, crossing each other, each consisting exclusively of dead ends.

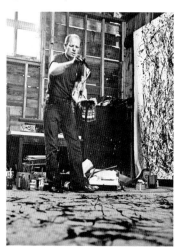

Jackson Pollock painting "Autumn Rhythm: Number 30", 1950

The 1950 paintings are still today at the focus of considerations of Pollock's work not least because at the time they were painted they were the objects of increased media interest. When in November/December 1950 *Number 1, 1950 (Lavender Mist)* and other pictures of this period were exhibited at the Betty Parsons Gallery, the prominent society photographer Cecil Beaton used them as the background for a series of fashion photos which were intended to proclaim the "new soft look" in the March 1951 edition of "Vogue". Above all, however, Pollock himself became a public figure when Rudolph Burckhardt and Hans Namuth photographed and filmed him at work from July to October 1950. Their pictures created the mythic, sexually charged image of Pollock as "Jack the Dripper" and hero of "Action Painting", making it available to a broad public; the films shot by Namuth were already being shown the following year at the Museum of Modern Art.

The year 1950 represents a caesura in Pollock's career in numerous ways. After the end of Namuth's filming in October 1950, Pollock started drinking again after four years' abstinence. To his friend Alfonso Ossorio, he described his psychological situation after the Betty Parsons exhibition as an "all-time low". Even though it is problematic in principle to relate biographical and artistic developments directly as through they were cause and effect, the crisis at the end of 1950 does point to a fundamental change in Pollock's work, which went hand-in-hand with a restriction, for a while, to the colour black, and a return to recognizably figurative elements. A whole variety of factors may have played a role.

Krasner, who had been married to Pollock since 1945, thought that he had reached the end point of his artistic development in 1950, and was not satisfied with thenceforth continually repeating himself. But the change in his working method may well have been a reaction to the media image (and the expectations that this involved) which had been created during this year. In June 1951 Pollock commented on his new black-and-white pictures to Alfonso Ossorio and Ted Dragon, emphasizing among other things his technical virtuosity as a draughtsman. "I've had a period of drawing on canvas in black – with some of my early images coming thru – think the non-objectivists will find them disturbing – and the kids who think it simple to splash a Pollock out."

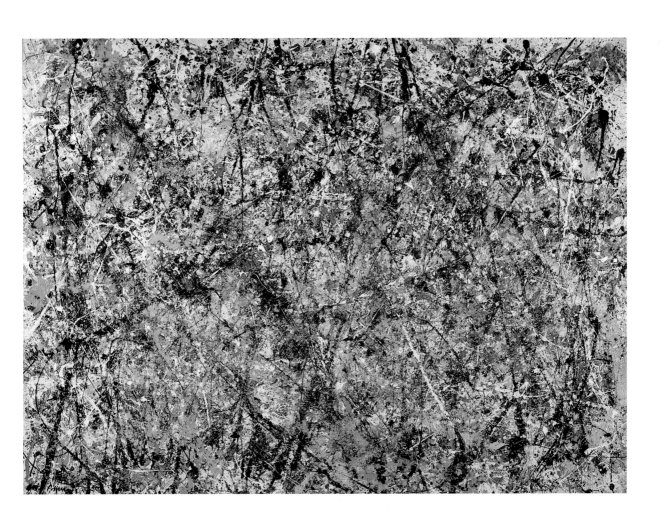

woman I

Oil on canvas, 192.8 x 147.3 cm
New York, The Museum of Modern Art

If we are to believe what we have been told, Willem de Kooning's doubtless best-known and at the same time most controversial work almost failed to see the light of day. In June 1950 de Kooning, who usually composed his pictures directly on the canvas, had begun work on preparatory drawings for *Woman I*. When the respected art historian Meyer Schapiro visited him in his studio in March 1952, de Kooning had rejected the picture as a definitive failure, and already resignedly removed the canvas from the stretcher. With Schapiro's encouragement de Kooning re-worked the painting, however, and soon brought the work to completion.

In March 1953 the picture was exhibited at the influential Sidney Janis Gallery together with five other works from the series entitled "Paintings on the Theme of the Woman". The magazine "Art-News" provided flanking support for the event by publishing the same month a lengthy article about the artist, among other things documenting in photographs the various stages in the difficult gestation process of *Woman I*. The same year as it was exhibited at the Sidney Janis Gallery, the picture was acquired by the Museum of Modern Art.

In spite of this success, de Kooning's *Women* came across to many beholders in the artistic and art-critical penumbra of the New York School, in which abstraction was being celebrated as a progressive achievement in the evolution of contemporary American painting, quite literally as a foreign body. In the oeuvre of the artist, the motif of the human figure, by contrast, had been present from the very beginning, and kept turning up, with interruptions during which abstract works came more to the fore, time and again, as for example in *Woman* (1948), which already heralded the later series.

De Kooning attempted to escape being pinned down to abstraction or figuration, and in 1960 declared in an interview: "Certain artists and critics attacked me for painting the *Women*, but I felt that this was their problem, not mine. I don't really feel like a nonobjective painter at all. Today, some artists feel they have to go back to the figure, and that word 'figure' becomes such a ridiculous omen – if you pick up some paint with your brush and make somebody's nose with it, this is rather ridiculous when you think of it, theoretically or philosophically. It's really absurd to make an image, like a human image, with paint, today, when you think about it, since we have this problem of doing it or not doing it. But then all of a sudden it was even more absurd not to do it. So I fear that I have to follow my desires."

The series *Women* was and is controversial not least on account of the seemingly negative image of woman which it presents, in which the depiction of the female figure functions as a projection surface for male aggression. In a wide-ranging discussion, the feminist art historian Linda Nochlin pleaded in 1998 above all for people to view the group of works with a discriminating eye: "I am not sure I can agree with any single evaluation of the *Women* series from the viewpoint of 'positive' or 'negative' gender representation. There is too much ambivalence here. And what, precisely, constitutes 'positive' or 'negative' when a cultural concept like 'woman' (in general) is at stake?"

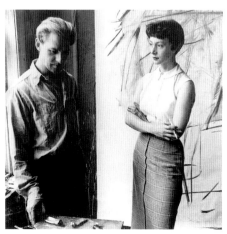

Elaine and Willem de Kooning, early 1950s

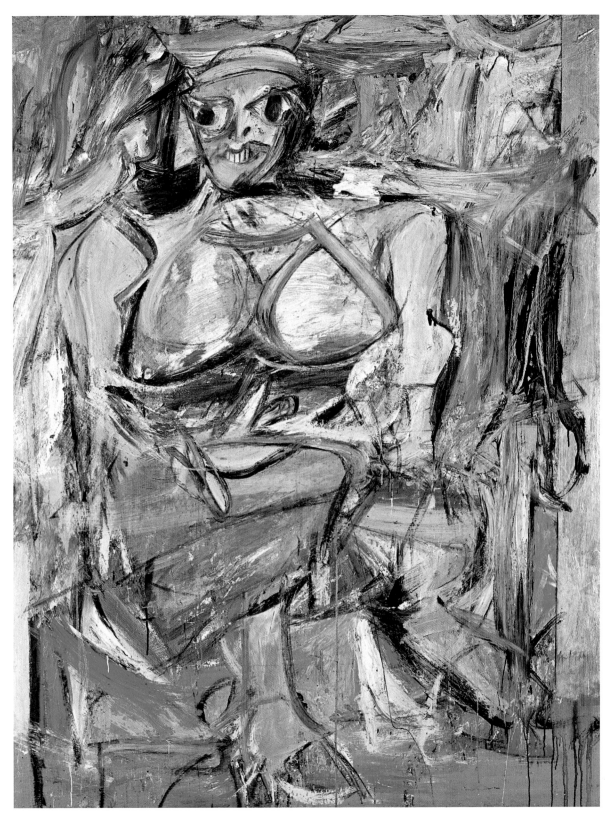

Hudson River Landscape

Carbon steel and stainless steel, 126.8 x 187.3 x 42.1 cm
New York, Whitney Museum of American Art

**b. 1906 in Decatur,
d. 1965 in Albany (USA)**

In Abstract Expressionism, sculpture played a subordinate role. Or, as Ad Reinhardt put it in 1957: "Sculpture is no problem. Nobody likes sculpture." The most prominent exponent of this medium in the context of the New York School is without a doubt David Smith, and Reinhardt's mordant observation is in tune with the fact that from the 1930s to the 1950s, Smith was able to sell very few works. It took a grant from the Guggenheim Foundation in the early 1950s to improve his situation. Smith gathered his first experiences in metal-working outside the field of art: as a student in 1925, he worked as a welder in a Studebaker car factory in South Bend, Indiana. In 1926 he moved to New York, where he studied painting and drawing at the Art Students League from 1927 to 1932. He obtained his knowledge of European avant-garde sculpture primarily from his acquaintanceship with the Russian exile John Graham, who played an important role among the Abstract Expressionists as a conduit of information concerning European art.

Inspired by illustrations of the wrought-metal sculptures of Pablo Picasso and Julio Gonzáles in the French magazine "Cahiers d'Art", Smith created his first sculpture of welded metal in 1933. A welding shop in Brooklyn placed rooms, appliances, materials and technical expertise at Smith's disposal for the production of his sculptures. When Smith moved in 1940 to the neighbourhood of Bolton Landing, New York, a remote township in the Adirondack Mountains, and there built a workshop to his own design, naming it "Terminal Iron Works" after the factory in New York. Smith described his workplace as "an industrial factory type… because the change in my sculpture required a factory more than an 'atelier'".

On his death in a car accident, Smith left a comprehensive oeuvre comprising more than 700 sculptures; his productivity, which increased in the final decades of his life, is regarded as partly due to strict organization of the production process and quasi-industrial form of manufacture. He often described his early employment in the car and railway industry as an important influence, an attitude which was also to become typical of a succeeding generation of American sculptors in the context of Minimal Art.

The process by which *Hudson River Landscape* was created was described by Smith in 1951 as follows: the design "started from drawings made on a train between Albany and Poughkeepsie… On this basis I started a drawing for a sculpture. As I began I shook a quart bottle of India ink, it flew over my hand, it looked like my landscape. I placed my hand on paper and from the image this left I travelled with the landscape to other landscapes. Is my work… the Hudson River, or is it the travel, the vision, the ink spot, or does it matter?"

A landscape is actually a rather unusual subject for a sculptor. Early beholders were surprised by the *Hudson River Landscape* with its, as Rosalind E. Krauss recalls, "insubstantiality of a paper cutout". And indeed, Smith's innovative work can also be described as a calligraphic drawing in three dimensions, bringing together various different elements – hints of bridges, steps, waves and a bird's skeleton – which do not allow the beholder countless views of equal status, but are best seen from the front.

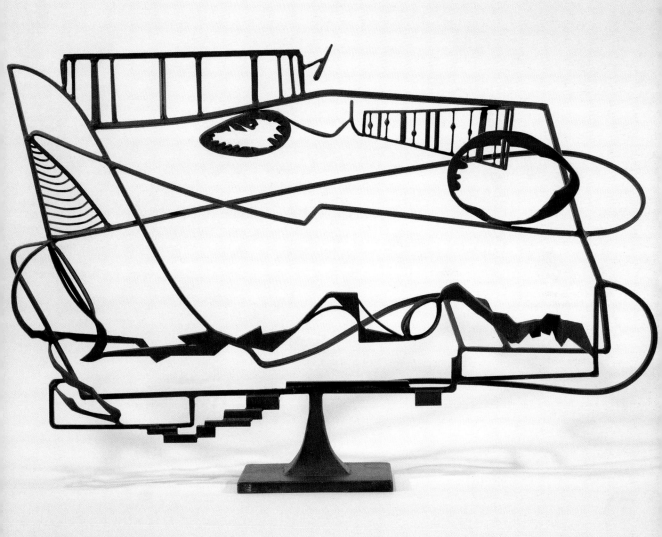

universal city

Watercolour on paper, mounted on hardboard, 95.3 x 63.5 cm
Seattle, Seattle Art Museum, Gift of Mr. and Mrs. Dan Johnson

b. 1890 in Centerville (USA),
d. 1976 in Basle (Switzerland)

"It may be a chronological fact," declared Clement Greenberg in his much-quoted 1955 essay "'American-type' Painting", "that Mark Tobey was the first to make, and succeed with, easel pictures whose design was 'all-over' – that is, filled from edge to edge with evenly spaced motifs that repeated themselves uniformly like the elements in a wallpaper pattern, and therefore seemed capable of repeating the picture beyond its frame to infinity. Tobey first showed his 'white writings' in New York in 1944, but Pollock had not seen them when he did his own first 'all-over' pictures in the late summer of 1946, in dabs and ribbons of thick paint that were to change at the end of the year into liquid spatters and trickles." As so often in Greenberg's writings, the mention of a particular artist – here Mark Tobey – serves as a foil against which he can all the more clearly bring out the originality of his favourite Jackson Pollock. Since then, the comparison between Pollock's and Tobey's all-over structures – and the question of their mutual influence – has returned time and again in debates on the New York School, for example when John Canaday, the art-critic of the "New York Times", mentioned the two very different artists in one breath in 1960: "Mark Tobey and Jackson Pollock (a philosopher and an athlete)."

Although the work of Tobey is often discussed using art-historical labels such as Abstract Expressionism, it is impossible to pin down to simple categories. Tobey, born in 1890, was markedly older than the inner circle of the New York School. He moved to the city in 1911, and exhibited there for the first time in 1917. In 1918 he took a decision which was to have a decisive influence on his later work, namely to join the Baha'i faith, whose principles and influences on his work he described in 1934: "The root of all religions, from the Baha'i point of view, is based on the theory that man will gradually come to understand the unity of the world and the oneness of mankind. It teaches that all the prophets are one – that science and religion are the two great powers which must be balanced if man is to become mature. I feel my work has been influenced by these beliefs. I've tried to decentralize and interpenetrate so that all parts of a painting are of related value."

During numerous stays abroad, including Japan and the Middle East, Tobey also took an interest in oriental calligraphy. In 1935, a year after he had spent a month in a Zen monastery near Kyoto, he started on his "White Writing" series: calligraphic signs painted on top of each other in white or pale colours on an abstract colour-field; the signs consist of countless enmeshed brush-strokes. At first, as in *Broadway* (1935), Tobey still based his work on specific places, but later he developed the motif of the city into symbolically abstract depictions of the *Universal City* in the spirit of Baha'i.

It was with a pronounced critical undertone that Greenberg, in his 1947 article "The Present Prospects of American Painting and Sculpture", said of Tobey that he had "turned out so narrow as to cease even to be interesting. Sensibility confined, intensified, and repeated […]": aesthetic qualities which in the 1960s were to enjoy a decisive re-evaluation and which have thus also contributed indirectly to Tobey's increasing appreciation since.

"ı have sought a unified world in my work and use a movable vortex to achieve it."

Mark Tobey

saint Honoré

Oil on canvas, 201 x 134.5 cm
Düsseldorf, K20 – Kunstsammlung Nordrhein-Westfalen

**b. 1923 in San Mateo,
d. 1994 in Santa Monica (USA)**

Sam Francis began to develop his painterly position in the first half of the 1950s. He thus belonged, to use Clement Greenberg's phrase, to the period "after Abstract Expressionism" and to an artist generation which had to confront the dominant influence of artists such as Barnett Newman, Jackson Pollock and Clyfford Still in order to create an independent profile for themselves.

Francis associated the start of his artistic career with a decisive autobiographical experience: in 1943, while training as a pilot for the US Air Force, he had a serious accident, as a result of which he had to spend a number of years lying in a plaster corset. It was in this situation that he took up painting in 1944, an activity to which he ascribed particular healing powers, and ultimately his recovery. In 1947 enrolled to study painting at the University of California at Berkeley. At this time, Clyfford Still and Mark Rothko were teaching at the California School of Fine Arts in nearby San Francisco; in spite of what one often reads, Francis was not one of their students, but was certainly familiar with their works through exhibitions in the region.

Unlike most of the representatives of the first generation of the New York School, Francis did not reject the European tradition. His decision in 1950 to go to Paris, where he lived until 1957, he explained in an interview in 1988: "I simply wanted to go to Paris; I didn't know what I wanted to do. I went my way. I wanted to be away from the USA. I had the impression that it was a prison and I wanted to see European art. I wanted to see true painting, no matter which." His primary interest in colorism, in light and colour, received major impetus through the encounter with French painting, in particular with Claude Monet's water-lily pictures, and the painting of Henri Matisse and Pierre Bonnard.

Francis developed his characteristic early-1950s painting technique in 1949–50: following the all-over principle, the whole surface of the picture is covered in biomorphous forms reminiscent of cells or petals executed in semi-transparent, runny paint. The diaphanous nature of the paint-application points to the superimposed colour-veils of Rothko's pictures, while the dripping streaks of paint develop Arshile Gorky's technique of the 1940s. In early-1950s' pictures such as *Saint Honoré*, which Francis included in a successful exhibition held at the Galerie du Dragon in Paris, he reduced his colour spectrum to dully glowing white and grey hues, recalling the characteristic milky light of the French capital.

Francis himself, however, was less interested in the descriptive function of colour, but constantly raised the question, in his aphorisms, of its spiritual and meditative dimension. According to the art historian Pontus Hulten, Francis, in allusion to Herman Melville's famous 1851 novel *Moby Dick*, had described his brush as the harpoon with which Captain Ahab hunted the white whale. In his later work too, the colour white, in particular as the empty middle of the picture, continued to be of great importance for his painting.

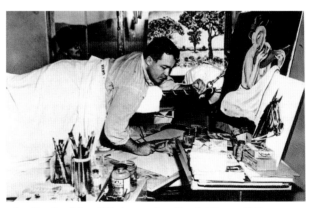

Sam Francis painting at Fitzsimmons Army Hospital, Denver, 1944

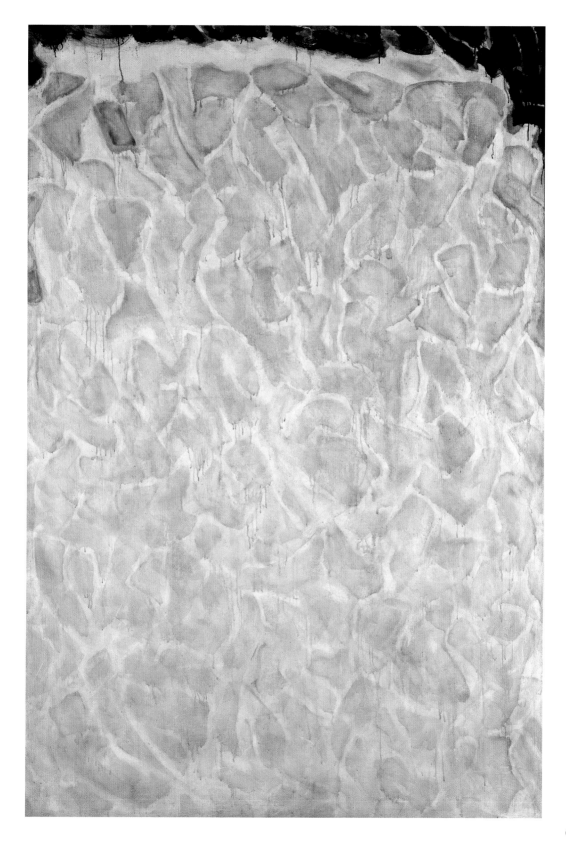

Number 5 (Red Wall)

Oil on canvas, 203.2 x 106.7 cm
Washington, D.C., Corcoran Gallery of Art, Gift of Gilbert H. Kinney, 1987.37

Unlike the Abstract Expressionist artists Willem de Kooning, Jackson Pollock or Mark Rothko (with whose circle Ad Reinhardt maintained contact, in spite of continually railing against their art) Reinhardt's own work was at no time figurative. From the outset in the 1930s, Reinhardt placed his early post-Cubist collages and his painting strictly in the tradition of abstract art. "It's been said many times in world art writing that one can find some of painting's meanings by looking not only at what painters do but at what they refuse to do," he observed in 1952. For Reinhardt the ultimate resistance consisted in "not confusing painting with everything that is not painting". References to the world of objects or the world of the artist's imagination were thus, for Reinhardt, programmatically excluded. In the painting of Abstract Expressionism, by contrast, he discerned an internal contradiction, which he summed up in 1966 as follows: "The tension between the abstract painters and the Surrealists was clear in the 1930s. Abstract Expressionism mixed them all up."

From 1950 to 1953, Reinhardt worked on series of red and blue pictures in a spectrum of closely similar colour tones, a principle which already points to the barely differentiated, monotone coloration of his extensive series of "black" pictures, which are regarded as Reinhardt's most important achievement. The vertical-format canvas *Number 5 (Red Wall)* is, on the all-over principle, covered with rectangular, in some cases overlapping shapes. The loose arrangement of forms is reminiscent of a collage, a medium in which Reinhardt had taken an intense interest in the 1930s.

It would be inaccurate to describe Reinhardt's red and blue pictures as monochrome, and yet Reinhardt, through his use of minimal tonal differentiation, avoided an "interaction of colour", thus achieving a more complex form of unity. Reinhardt taught in 1952–53 in the art department of Yale University, where one of his colleagues was the German émigré, the former Bauhaus teacher Josef Albers (1888–1976). In 1950, Albers had begun his best-known and most extensive group of works *Homage to the Square*, square pictures in which he investigated the perception of the interaction of three or four square colour fields, in echelon one behind the other. Albers published the results of this investigation in 1963 in the book *Interaction of Color*.

Reinhardt's red and blue pictures of the early 1950s and the transformation that his painting underwent in 1953 are to be seen not least with reference to a confrontation with Albers' project. Thus in his "Chronology", dating from 1966, he writes: "1953 Gives up principles of asymmetry and irregularity in painting", and "1953 Paints last paintings in bright colors." While the first change could be seen as a tribute to Albers' *Homage to the Square* (where the pictures are symmetrical and regular), the second decision, namely the renunciation of bright colours, represents a turning-away from Albers' painterly investigations of colour. When the red and blue paintings were publicly exhibited, critics noticed such characteristics as their decorative quality and "beauty", characteristics that Reinhardt sought to remove in his "black" paintings.

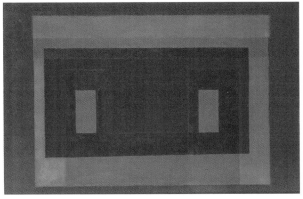

Josef Albers, Variation in Red and Orange around Pink, Ochre, Plus Two Reds, 1948

urbana NO. 6

Oil on canvas, 173.5 x 147 cm
Fort Worth, Modern Art Museum of Fort Worth, Museum purchase, Sid W. Richardson Foundation Endowment Fund

**b. 1922 in Portland,
d. 1993 in Berkeley (USA)**

"On the farther shore of Abstract Expressionism" was the title in 1996 of the first chapter of a catalogue relating to the San Francisco School. The Abstract art which arose from the 1940s to the mid-1960s in the Bay Area was for a long time largely regarded as a reflection and further development of influences emanating from the New York School, not least because Mark Rothko and Clyfford Still had taught at the California School of Fine Arts in San Francisco in the late 1940s. Here, though, the question of the autonomy of a West Coast variant of Abstract Expressionism was indeed raised, a variant which was seen to be in itself no less varied and heterogeneous than its East Coast relation.

It is true that artists on both sides of the continent were reacting to a broader international cultural and political situation, and that mutual exchange was promoted by their teaching activities and by joint exhibitions. At the same time, though, a number of local factors have to be taken into consideration, such as the influence of the beatnik subculture in San Francisco, the characteristic West Coast orientation towards Asia, and a greater artistic confrontation with the landscape.

Richard Diebenkorn grew up in San Francisco, and after a period of service with the Navy during the Second World War, returned there in 1946. He studied at the California School of Fine Arts, where he took up a teaching post himself in 1947. His painting style, which hitherto had been strongly influenced by Still, among others, changed when he continued his studies in Albuquerque, New Mexico, in 1950–51; encouraged by the distance he had put between himself and his earlier influences, his application of paint became more fluid, the nuances brighter.

In Albuquerque Diebenkorn also began to take a greater interest in the landscape, as hinted at by the titles of his picture series dating from the first half of the 1950s – *Albuquerque*, *Urbana*, *Berkeley*: "Temperamentally, perhaps, I had always been a landscape painter," noted Diebenkorn, "but I was fighting the landscape feeling. For years I didn't have the color blue on my palette because it reminded me too much of the spatial qualities in conventional landscape. But in Albuquerque I relaxed and began to think of natural forms in relation to my own feelings." This lyrically tinted confrontation with impressions of nature and the landscape was incidentally something Diebenkorn shared with other artists of the second generation of Abstract Expressionism, such as Helen Frankenthaler or Joan Mitchell.

Diebenkorn's *Urbana* series, with its colour-fields criss-crossed by lines, was also influenced by two further decisive experiences: the visit of a Matisse retrospective to Los Angeles in 1952 and a flight from Albuquerque to San Francisco the previous year, both of which opened up to the artist a new, abstract way of looking at the landscape, as he recalled in a conversation with Gerald Nordland in 1986: "The aerial view showed me a rich variety of ways of treating a flat plane – like flattened mud or paint. Forms operating in shallow depth reveal a huge range of possibilities available to the painter."

After a figurative intermezzo from 1955 to 1967, Diebenkorn returned in the late 1960s, with his doubtless best-known and most extensive series *Ocean Park*, to the genre of "abstract landscape", a label which "Life Magazine" had coined for his work back in 1954.

Easter and the Totem

Oil on canvas, 208.6 x 147.3 cm
New York, The Museum of Modern Art, Gift of Lee Krasner in memory of Jackson Pollock, 1980

Jackson Pollock's final period, between 1952 and 1954, saw the appearance of few pictures, and these not uniform in style. They convey the impression of a search for possible directions to pursue. In the process, Pollock had recourse to elements of his own work that preceded the "classic" drip-paintings of the years 1947 to 1950, but at the same time integrated influences from other sources, including his favourite European "rivals" Pablo Picasso and Henri Matisse. Thus *Easter and the Totem*, painted conventionally with a brush, recalls in point of composition and coloration two pictures by Matisse, *Bathers by the River* (1916) and *The Moroccans* (1915–16), which were exhibited at the Museum of Modern Art in 1951. Clement Greenberg, who in the late 1940s and early 1950s had doubtless been Pollock's most influential supporter, criticized these late works for what he saw as their self-imposed restriction to technical virtuosity. In 1967 Green-berg described the years between 1952 and 1954 as a phase, in which "he [Pollock] displayed proficiency in an obvious enough way to win admission to any guild of 'good' painters". Pollock himself, by contrast, in a 1956 interview, stressed his identification with a figurative style of painting which he described as psychologically motivated: "I'm very representational some of the time, and a little all of the time. But when you're painting out of your unconscious, figures are bound to emerge. We're all of us influenced by Freud, I guess. I've been a Jungian for a long time… Painting is a state of being… Painting is self-discovery. Every good artist paints what he is."

With the motif of the totem, a pillar cut off by the left-hand edge of the picture, Pollock was using a symbolism which had interested him since the late 1930s after undergoing psychotherapy with Joseph Henderson, a pupil of C. G. Jung. In Jung's opinion, the contents of the collective unconscious, which were forged at the beginning of human history, have been re-born in every individual ever since. Already in the late 1930s Pollock had thematized the motif of birth in an eponymous painting dating from c. 1938–1941, which makes use of the forms of native American masks. Several visits to the exhibition "Indian Art of the United States" at the Museum of Modern Art in 1941 reinforced Pollock's interest in native American culture and its basic features, such as totemism.

With the reference to the native American totem – an animal, bird, plant or force of nature, which is regarded as the ancestor of a social group and which is believed to have magical powers – and to Easter as the Christian festival of the Resurrection, Pollock seems to be taking up the motif of birth once more as "re-birth". His personal crisis and reduced artistic creativity in the years after 1952, which followed a relapse into alcoholism in November 1950, were in inverse proportion to his rapid rise to international artistic fame. Even Pollock's last exhibition during his lifetime, at the gallery of the successful dealer Sidney Janis in November 1955, was presented as a retrospective by reason of his inability to paint. The financial magazine "Fortune" recommended his works in 1955 as investments with growth potential, a prognosis that was to be fulfilled soon after Pollock's death in August 1956.

Totem Lesson 2, 1945

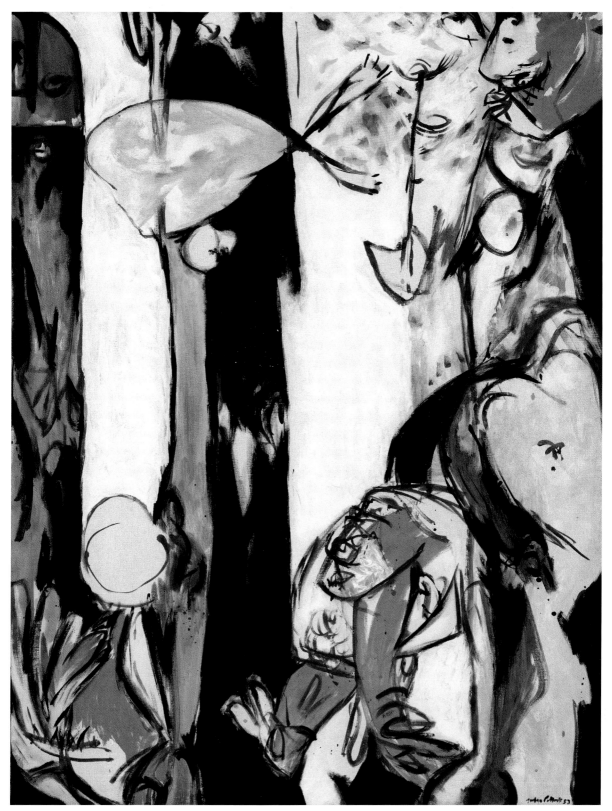

Elegy to the spanish Republic, NO. 34

Oil on canvas, 203.2 x 254 cm
Buffalo, Albright-Knox Art Gallery, Gift of Seymour H. Knox, Jr., 1957

b. 1915 in Aberdeen,
d. 1991 in Provincetown (USA)

Consisting of more than two hundred paintings, the *Elegies to the Spanish Republic* represent one of Robert Motherwell's most extensive group of works. It occupied the artist for more than thirty years. The end of the young Spanish Republic had been sealed in 1939 with the victory of the fascist dictator Francisco Franco following the devastating three-year civil war. The *Elegies* series was not begun until a good ten years later.

The occasion for the black-and-white Indian-ink drawing *Ink Sketch (Elegy No. 1)* was a poem by Harold Rosenberg, "The Bird for Every Bird", which appeared in 1948 in the first and only edition of the magazine "Possibilities" – a project on which Motherwell, Rosenberg, John Cage and Pierre Chareau formed the editorial staff. On the model of the French magazine "Verve", Motherwell wrote the poem, which has nothing to do with the Spanish Civil War, out by hand and "illustrated" it with an abstract drawing.

The basic elements which were to characterize the whole series are already apparent in the first sketch: the picture surface is rhythmatized by vertical elements, between which oval forms are enclosed. Motherwell was employing the Surrealist technique of "écriture automatique", to the extent that the first thing he did was apply a spontaneous arrangement of Indian-ink lines to the paper. Unlike Surrealists, however, he did not seek as a next step to create a figurative design from the result, but rather an abstract composition. It was not until an exhibition at the Samuel Kootz Gallery in December 1950, where Motherwell displayed a number of pictures from the series, that he gave them the title *Elegies (to the Spanish Republic).*

Elegy to the Spanish Republic, No. 34 was described by Motherwell as "one of the half-dozen most realized of the Spanish Elegy Series", having been created during what the artist described as a "painting block", in which he spent a lot of time "realizing" details. The background colours are a reference to the flag of the Spanish Republic in yellow, red and blue.

In a 1963 interview, Motherwell commented on the *Elegies* as follows: "I take an elegy to be a funeral song for something one cared about. The *Spanish Elegies* are not 'political', but are my private insistence that a terrible death happened that should not be forgot. They are as eloquent as I could make them. But the pictures are also general metaphors of the contrast between life and death and their interrelation." The colours white and black, which play a central role in the *Elegies* series, symbolize according to Motherwell this universal dualism of life and death. Even though Motherwell himself said that the *Elegies* were not political, the topic nevertheless had a political currency, as Spain remained a dictatorship until Franco's death in 1975, and only adopted a democratic constitution in 1978.

Another widespread, quasi-psychological reading of the *Elegies* is the interpretation of their organic, oval and vertical forms as symbols of the male and female sexes, or as the phallus and testicles of a slaughtered bull on a white wall.

Ink Sketch (Elegy No. 1), 1948

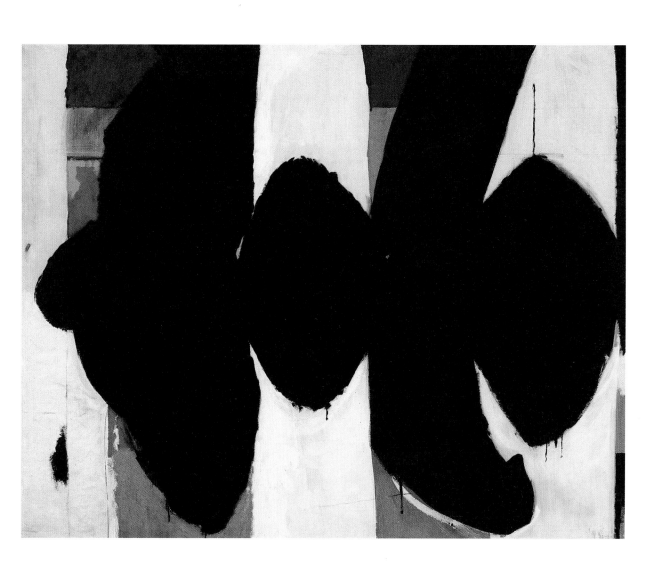

ochre and Red on Red

Oil on canvas, 235.5 x 162 cm
Washington, D. C., The Phillips Collection

In 1949, after the transitional phase of the so-called "multi-forms", Mark Rothko settled down to his characteristic, horizontal arrangement of colour-fields on a monochrome background, which he retained with a few variations until the end of his painting career. His decision to work with large formats, already apparent in earlier phases of his work, was explained by Rothko in 1951 on the occasion of a symposium on the potential of a link-up between architecture, painting and sculpture: "I paint very large pictures. I realize that historically the function of painting large pictures is painting something very grandiose and pompous. The reason I paint them, however – I think it applies to other painters I know – is precisely because I want to be very intimate and human. To paint a small picture is to place yourself outside your experience, to look upon an experience as a stereopticon view or with a reducing glass. However you paint the larger picture, you are in it. It isn't something you command."

Subsequently Rothko tried to determine as far as possible for himself how his pictures were to be presented: the selection, the hang, the illumination. Thus Philip Guston recalled going to an exhibition of Rothko's work at the Sidney Janis Gallery, in which Rothko had switched off half the lamps in order to create a dim light: "I'm positive that Mark sneaked up there every day and turned the lights down – without ever complaining or explaining."

Rothko's sensitivity in the matter of how his works were to be treated required a relationship of close trust to his collectors and curators, who had to be ready to accept the unmistakable conditions laid down by the artist. Thus he succeeded, on the occasion of the "Fifteen Americans" exhibition at the Museum of Modern Art in 1952, which was curated by Dorothy Miller, in being assigned a room of his own in which to exhibit nine pictures. In numerous other cases, he refused to take part in group exhibitions or to submit proposals to purchasing committees if he regarded the expected presentation as inappropriate.

Against this background the collaboration between Rothko and the Washington collectors Marjorie and Duncan Phillips has a model character. The collectors, who had acquired two of his works as early as 1957, had their home enlarged in 1960 by the addition of a museum wing. Here, one room was devoted to three large-format pictures by Rothko, the first permanently installed Rothko room in collection open to the public. One of these pictures was *Ochre and Red on Red*. Rothko viewed it a year later, corrected the lighting conditions, and asked for the inclusion of a bench for visitors to sit on. In 1966, the museum was re-built, which involved a re-hang of the Rothko collection, which has since comprised four pictures.

As early as 1952, Rothko, in a letter to the co-director of the New Yorker Whitney Museum, had explained his feeling of responsibility for "the life my pictures will lead out in the world"; from the late 1950s he was to place the space-centred working-method already hinted at in the permanent hang of the Phillips Collection, at the focus of his artistic activity.

The Rothko room, room installation, The Phillips Collection

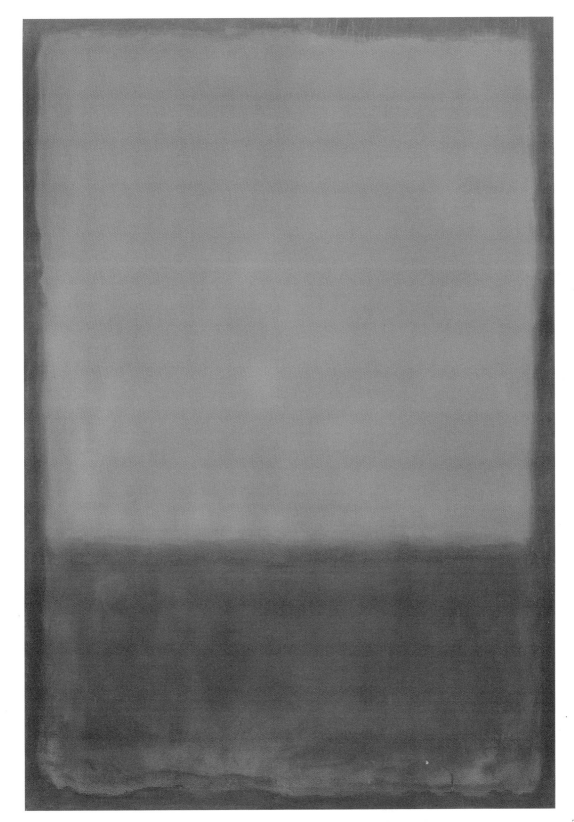

FOr M

Oil on canvas, 193.99 x 183.52 cm
San Francisco, San Francisco Museum of Modern Art, Anonymous gift

In the work of Philip Guston, abstraction was an episode which was largely confined to the late 1940s and the 1950s. Like most fellow artists of his generation, he was averse to being called an Abstract Expressionist or to the idea that painting could be fulfilled in a simple self-investigation of the medium. "As a matter of fact, I don't remember in any of the get-togethers I had with painters of that period that that word was exchanged. Nobody ever said, you so-and-so abstract-expressionist, you," recalled Guston in the 1960s.

In the early 1950s, Guston developed a type of picture, new in his work: this consisted of vertical and horizontal brush-strokes, thickly applied, either crossing or cancelling each other out, getting denser towards the centre of the picture and increasing in colour intensity. It is as though a kind of moving veil, "a fog of muted tones", had been laid over the motif. The axial orientation of the brush-strokes has often been compared to Piet Mondrian's "plus-minus-pictures" of the mid-1910s. Starting from the motif of a clear starry night over the sea, the crossing lines hinting at its glittering reflections, Mondrian's *Compositions* stand at the transition from Cubism to his abstract grid compositions. In addition, Guston's choice of pastel shades in works such as *For M* recalled for many a beholder, on a formal plane, the painting of the Impressionists, so that Louis Finkelstein in a 1956 article in "ArtNews" could speak of Guston's "Abstract Impressionism".

Guston himself described the – figurative or abstract – works of artists who stimulated him as "living organisms" and the painting process as a dialogue with the picture, whose significance was difficult of access even to the painter. As he explained in 1966: "So as I was going to say, for reasons that I do not understand, the late 1940s, early 1950s, when I went into non-figurative painting, although I felt I was even involved with imagery even though I didn't understand the imagery completely myself, but I thought it was imagery, and for some reasons that's not quite clear to me yet and maybe I don't want to be clear about it either…"

This gesture of refusal was interpreted by some critics as a form of repression of traumatic experiences, either private or social, which were vividly present in Guston's painting of the 1930s and 40s, and which returned with a vengeance in the late 60s. Thus in the 1930s Guston's pictures were full of the gruesome deeds of the masked members of the racist Ku Klux Klan – a motif from his southern Californian environment, which in the late 1960s turned up again in his paintings and drawings. Guston shocked sections of the public with his grotesque figures and everyday objects, recalling his early enthusiasm for comics, such as nail-studded shoe-soles. From the orthodox perspective of Abstract Expressionism, the return to pictorial narrative was a breach of taboo, "like I had left the Church, and had been excommunicated," he remarked.

Sleeping, 1977

Bald Eagle

Oil, paper and canvas on linen, 195.6 x 130.8 cm
Los Angeles, Collection Audrey Irmas, Courtesy Robert Miller Gallery, New York

Following the *Little Images* series of the late 1940s, Lee Krasner's collages of the years 1953 to 1955 form her second extensive group of works. Krasner's break with the working method employed in *Little Images* cannot simply be explained by a series of critical reactions to these works. Even so, they offer a penetrating insight into the public perception of the relationship between Krasner's work and that of Jackson Pollock. The couple had taken part in the "Artists: Man and Wife" group exhibition at the Sidney Janis Gallery in 1949, where Krasner displayed one of her *Little Images*. In the magazine "Art-News", the publication that set the tone for Abstract Expressionism at this period, Gretchen T. Munson wrote in a review of October 1949: "There is also a tendency among some of these wives to 'tidy up' their husbands' styles. Lee Krasner (Mrs. Jackson Pollock) takes her husband's paints and enamels and changes his unrestrained, sweeping lines into neat little squares and rectangles."

Rhetorically, Krasner was thus reduced — by another woman, mark! — to the stereotype of the houseproud housewife, something to which other critics were also not averse. A more complex interaction between Krasner's and Pollock's painting techniques and their respective particularities was faded out in favour of the idea of a one-sided influencing of Krasner's work by her husband.

In October 1951, Krasner had her first solo exhibition at the Betty Parsons Gallery; from the point of view of sales, it was a failure. When Pollock left the Betty Parsons Gallery that same year for the commercially more successful Sidney Janis, Krasner had also to leave the gallery at Parsons' behest. Of the 14 pictures that she had shown there in 1951, she overpainted twelve and used some of them as canvases for new works, a series of collages. After the fiasco at the Parsons gallery, Krasner had at first completed a few black-and-white works on paper in 1953. Dissatisfied with the result, she took the drawings off the wall, tore them up, and threw the shreds on the floor. Not until a few weeks later did she return to her studio, as she recalled in an interview given in 1980: "When I opened the door and walked in, the floor was solidly covered with these torn drawings that I had left and they began to interest me and I started collaging. Well, it started with drawings. Then I took my canvases and cut and began doing the same thing, and that ended in my collage show in 1955." This show took place in the renowned Stable Gallery to critical applause, at a time when Pollock was producing no new work.

In *Bald Eagle* Krasner uses not only her own canvases; the elements with squirts of black paint, including the piece in the centre of the picture, whose shape is reminiscent of an eagle's head, obviously derive from a rejected picture of Pollock's. Among the inspirations for Krasner's collages are considered to be the "découpages", or cut-outs, by Henri Matisse, of which she thought highly, and works by Anne Ryan, an artist friend. What seems remarkable about Krasner's approach to her large-format collages is that like Pollock's drip-paintings of 1950 they are in a sense painted from a horizontal perception, insofar as Krasner saw the arrangement of the torn-up drawings as in an "all-over" on the floor of her studio.

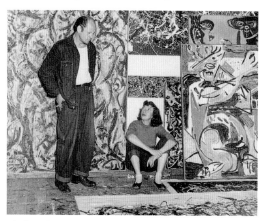

Jackson Pollock and Lee Krasner, 1949

Hemlock

Oil on canvas, 231.1 x 203.2 cm
*New York, Whitney Museum of American Art, Purchase, with funds from the
Friends of the Whitney Museum of American Art*

**b. 1926 in Chicago (USA),
d. 1992 in Paris (France)**

"My painting is not an allegory, it is not a story. It is more like a poem," declared Joan Mitchell in the 1980s. Mitchell was born into a home that promoted and encouraged her literary and artistic ambitions from her childhood onwards. Her father was a respected doctor who painted and sketched in his spare time; her mother was a poet and published the noted literary magazine "Poetry".

At an early age, Mitchell herself got to know important works of European art in the collection of the Art Institute of Chicago. In 1947, she moved to New York; in 1948–49 she was awarded a travel grant, which enabled her to work as an artist both in Paris and in the south of France. After her return to New York, in 1951 she became, alongside Lee Krasner, Elaine de Kooning and Helen Frankenthaler, one of the few women members of the Eighth Street Club, and participated in major group exhibitions such as the "Ninth Street Show" organized by Leo Castelli in 1951.

Not only experiences of the countryside and the natural world, but also literary texts, often form the reference points for Mitchell's gestural abstractions. The title *Hemlock* (it refers to the conifer) she took from a poem by Wallace Stevens, "Domination of Black", but only supplied it once the picture was finished. The title invites us to interpret the brush strokes in green and blue – which seem to be hurled outwards from the middle of the picture by some centrifugal force – as the branches of a conifer in a snowstorm.

For Mitchell herself, the colour white, which was often dominant in her pictures at this period, had a series of negative meanings, which go beyond its descriptive characteristics: "It's death. It's hospitals. It's my terrible nurses. You can add in Melville, 'Moby Dick', a chapter on white. White is absolute horror, just horror. It is the worst."

In the late 1950s, Mitchell's work came to enjoy increasing recognition. 1957 saw the appearance of the first detailed monograph on her work in "ArtNews"; in 1958, *Hemlock* was displayed at the exhibition "Nature in Abstraction: The Relation of Abstract Painting and Sculpture to Nature in Twentieth Century American Art" at the Whitney Museum in New York, and in this context purchased by the museum.

Unlike the majority of New York artists assigned to the category "Abstract Expressionists", Mitchell did not demonstratively seek to demarcate herself from the European painting tradition. On the contrary, she lived and worked from 1955 to 1959 both in the USA and in Paris. In 1959 she finally settled in France; thenceforth, her pictures were painted exclusively there, in spite of regular trips to the USA. This point of time, at the end of the 1950s, also marked a caesura in the post-war art scene. Thus in 1959 Mitchell also took part in the documenta II exhibition in Kassel, which finally sealed the international acceptance of Abstract Expressionism and thus laid the foundations for American art's claim to world leadership in the coming decade.

At the same time, within the New York art scene, criticism was increasingly being voiced to the effect that the painterly language of Abstract Expressionism, in particular in its interpretation by the second generation, to which Mitchell belonged, and their successors, was threatening to become an academic commonplace. The rise of new art movements was casting its shadow: "Pop Art, Op Art, Flop Art and Slop Art," observed Mitchell ironically in the mid-1970s. "I fall into the last two categories."

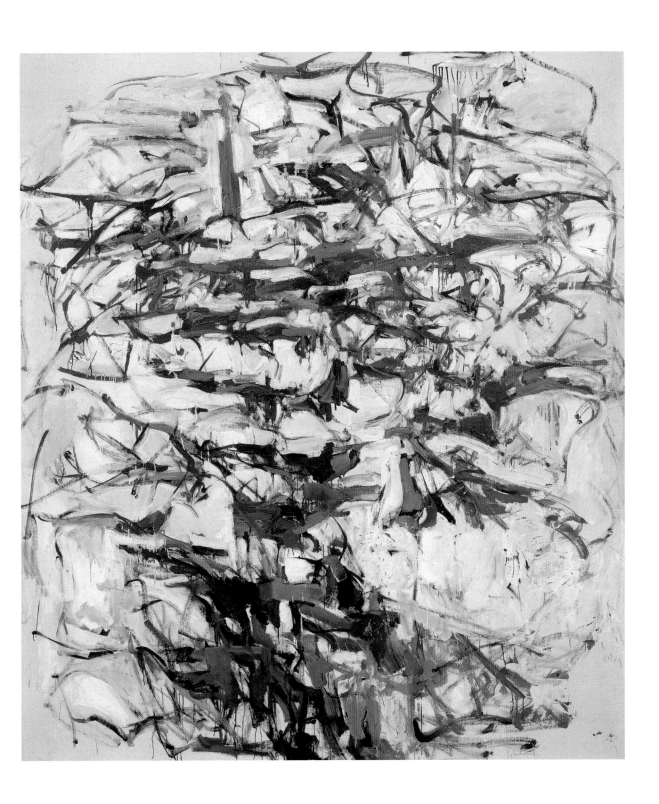

seven types of ambiguity

Oil on unprimed canvas, 242.6 x 178.1 cm
Private collection

b. 1928 in New York (USA)

On 26 October 1952, Helen Frankenthaler painted her perhaps most famous picture, the monumental *Mountains and Sea*. It was inspired by impressions gained on her travels: "I painted *Mountains and Sea* after seeing the cliffs of Nova Scotia," the artist recalled in 1997. "It's a hilly landscape with wild surf rolling against the rocks. Though it was painted in a windowless loft, the memory of the landscape is in the painting, but it has also equal amounts of Cubism, Pollock, Kandinsky, Gorky."

Frankenthaler had begun to study painting after leaving school in 1946; when she took part in a group exhibition at the Seligman Gallery in New York in 1950, one of those she invited was the influential critic Clement Greenberg, who soon became a close friend, promoting her work. In *Mountains and Sea* she used her characteristic "soak-stain technique" for the first time: the paint is applied to unprimed canvas. Oil-paints, heavily diluted with turpentine or paraffin, penetrate the fibres of the canvas and produce a watercolour effect. In fact, Frankenthaler had already worked in watercolour on paper, as for example *Great Meadows* (1951). The unity of paint and canvas conspicuously emphasizes the flatness of painting as a medium; thus Frankenthaler's *Mountains and Sea* fulfilled a central criterion of modern painting in Greenberg's sense.

Following Jackson Pollock's example, *Mountains and Sea* was painted on a canvas spread out on the floor. And just like Pollock, Frankenthaler did not apply the paint with a brush, but poured it from various containers on to the canvas, but without touching the latter directly; after this, the paint was rubbed into the cloth in places using a sponge. Her biographer Barbara Rose says that the decisive impetus for this – at the time – novel technique came from the artist's viewing of Pollock's black-and-white pictures at the Betty Parsons Gallery in 1951 and from a visit to his studio at The Springs on Long Island. In addition, Pollock's dripping technique had been made known by photographs taken by Hans Namuth and published in the magazine "ArtNews" in 1951.

Frankenthaler however stressed the difference between Pollock's approach to the act of painting, and her own: "I had no desire to copy Pollock. I didn't want to take a stick and dip it in a can of enamel. I needed something more liquid, watery, thinner. All my life, I have been drawn to water and translucency. I love the water; I love to swim, to watch changing seascapes. One of my favorite childhood games was to fill a sink with water and put nail polish into it to see what happened when the colors burst up the surface, merging into each other as floating, changing shapes."

Frankenthaler, who is reckoned among the second generation of Abstract Expressionists, not only established with *Mountains and Sea* her characteristic painting style at the early age of 23, she carried it on in pictures such as *Seven Types of Ambiguity*; this picture also influenced the younger artists Morris Louis and Kenneth Noland, who saw *Mountains and Sea* for the first time when visiting her studio in April 1953.

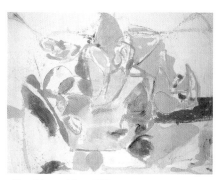

Mountains and Sea, 1952

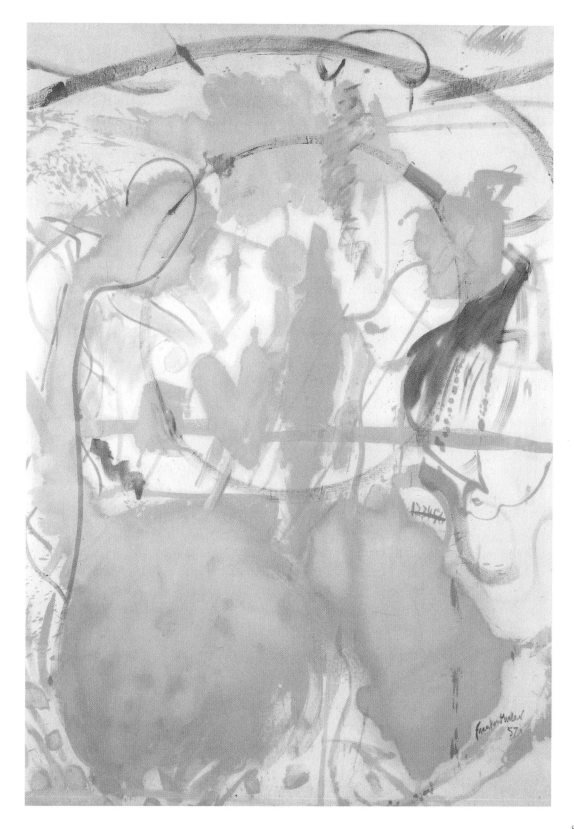

Blast, I, 1957

Oil on canvas, 228 x 114 cm
New York, The Museum of Modern Art, Philip Johnson Fund

**b. 1903 in New York,
d. 1974 in New York (USA)**

When the "New York Times" art-critic Edward Alden Jewell expressed his "befuddlement" concerning the pictures of Adolph Gottlieb and Mark Rothko, the two artists, in collaboration with Barnett Newman, replied in a letter to the editor, which was published in the paper on 13 June 1943. This reply is still regarded as a kind of manifesto of American painting in the early 1940s. In it, the authors stressed the following aesthetic convictions:

"1. To us art is an adventure into an unknown world, which can be explored only by those willing to take the risk.

2. This world of imagination is fancy-free and violently opposed to common sense.

3. It is our function as artists to make the spectator see our way, not his way.

4. We favor the simple expression of the complex thought. We are for the large shape because it has the impact of the unequivocal. We wish to reassert the picture plane. We are for flat forms because they destroy illusion and reveal truth.

It is a widely accepted notion among painters that it does not matter what one paints as long as it is well painted. This is the essence of academism. There is no such thing as a good painting about nothing. We assert that the subject is crucial and only that subject-matter is valid which is tragic and timeless. That is why we profess spiritual kinship with primitive and archaic art."

During the 1920s, Gottlieb had studied at the Art Students League and the Parsons School of Design (among other places) in New York, as well as at the Académie de la Grande Chaumière in Paris. During this decade he travelled around Germany and France. His contacts with the European Surrealists confirmed him in his opinion that art could be an expression of the unconscious, and rein-forced his interest in archetypal motifs. Against this background, from 1941 he developed the first of his two extensive groups of works, the so-called "Pictographs". These go back to an "archaic" or "primitive" imagery, such as the pictograms of the native Americans, which they embed in grid compositions, which likewise were inspired by narrative pictorial schemas of the Italian early Renaissance as well as by Giorgio de Chirico's Pittura metafisica.

In 1956–57 Gottlieb struck out on a new path: the extensive series known as "Bursts" marked the start of a major simplification in the motifs of his painting. On vertical-format canvases, against a spatially undefined, atmospheric background, two vertically arranged shapes, the top one round and more clearly contoured, the bottom one if anything chaotically eruptive, confront each other. The configuration of the two shapes allows numerous interpretations, extending from abstract landscapes to symbols of rival forces. It is revealing that Gottlieb gave the pictures in the "Bursts" series different names – such as *Blast, I, 1957*, *The Crest* (1959), *Counterpoise* (1959) or *Bullet* (1971) – and thus suggested constantly new interpretations of the motif himself.

Gottlieb also translated the motif of the "Bursts" into a series of sculptures, which represent some of the few contributions of this medium to Abstract Expressionism.

"My favorite symbols were those which I didn't understand."

Adolph Gottlieb

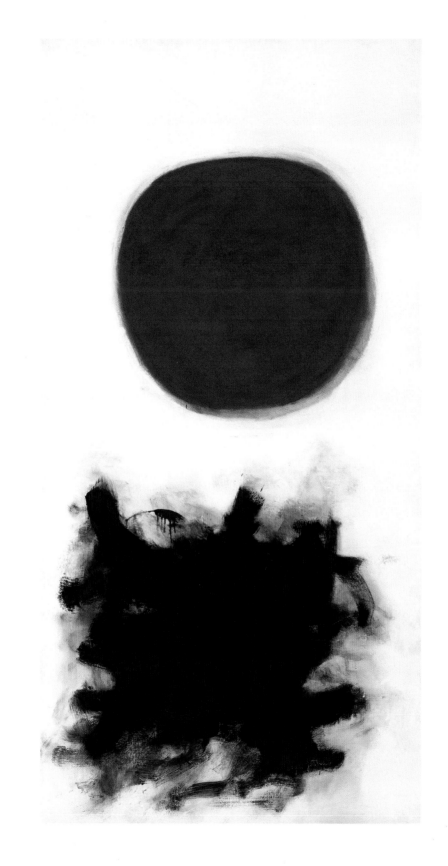

untitled

Oil on canvas, 200 x 158 cm
Düsseldorf, K20 – Kunstsammlung Nordrhein-Westfalen

**b. 1910 in Wilkes-Barre,
d. 1962 in New York (USA)**

From the late 1930s until the mid-1940s Franz Kline often derived the motifs of his then still figurative pictures from his home region, a mining district in eastern Pennsylvania. And the dynamic compositions of his later abstract works, painted after the mid-1940s, are often reminiscent of the characteristic colliery winding-towers of this region, known there as "tipples", their wooden structures coming across as rickety and not built to last. These regional references are further underlined by the titles of the pictures, which refer to the names of towns or railways in the region.

Even though Kline broadened his colour spectrum during the course of the 1950s, in particular after his arrangement with the Sidney Janis Gallery in 1956, he is known above all for his black-and-white pictures. *Cardinal* – according to Kline the name of a railway – was first exhibited on the occasion of his first one-man show at Charles Egan's gallery in the autumn of 1950. At this time, other painters of the New York School, in particular Willem de Kooning and Jackson Pollock, were reducing their colours to black and white. Clement Greenberg explained this choice in his 1955 essay "American-type' Painting" as an art-historically important further development of chiaroscuro, which in his view constituted the basis of painting. "And the new emphasis on black and white has to do with something that is perhaps more crucial to Western painting than to any other kind."

It is true that Kline had also concerned himself with Oriental art, and as an art student in London in the late 1930s he had collected Japanese prints; for this reason, his black-and-white pictures were often linked to Japanese calligraphy, as with *Untitled* in 1957. Kline himself explicitly rejected any such comparison, as he did not work only with black paint on a white ground, but also overpainted black with white and white with black, thus building up his motifs step by step. His working method, which involved taking weeks or months over a picture, during which time he would work on a number of canvases in parallel, is also not comparable with the rapid execution of an Indian-ink drawing on paper. "The Oriental idea of space is an infinite space; it is not painted space, and ours is," said Kline in an interview in 1962. "In the first place, calligraphy is writing, and I'm not writing. People sometimes think I take a white canvas and paint a black sign on it, but this is not true. I paint the white as well as the black, and the white is just as important."

The starting point for Kline's pictures was often a spontaneous sketch, which for reasons of expense he often executed on the pages of telephone directories or on newspaper. In about 1948, in de Kooning's studio, Kline learnt about the potential applications of the Bell-Opticon, an enlargement appliance which allowed drawings to be projected on to a wall. It was when projecting some of his black-and-white drawings that Kline came upon his characteristic technique: transferring the configurations of the drawings – but without the help of a projector – on to large-format canvases.

> "The thing is that a person who wants to explore painting naturally reflects: 'How can I in my work be most expressive?' Then the forms develop."
>
> **Franz Kline**

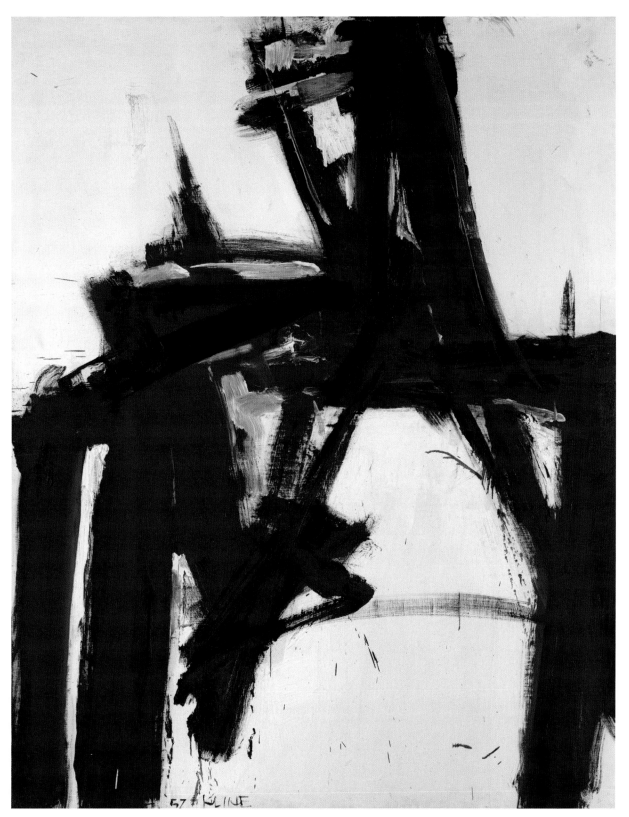

First station

from the series "Stations of the Cross – Lema Sabachthani", 1956–1958, Magna on canvas, 198.1 x 152.4 cm
Washington, D. C., National Gallery of Art, Robert and Jane Meyerhoff Collection

"If the 1930s and early 1940s were 'limbo' for him, 1955 through 1960 was his inferno," remarked Thomas B. Hess in the catalogue that appeared in 1971 to accompany the posthumous Barnett Newman retrospective in the Museum of Modern Art. Both in the general public attention given to his works, and also in respect of their sale, Newman at the time was well behind such fellow artists as Franz Kline, Jackson Pollock, Mark Rothko or Willem de Kooning – a situation which did not begin to change until 1959, and then only gradually. The years 1956 and 1957 were in addition years of crisis as far as his creativity were concerned, giving rise to no new works. Finally in November 1957 he suffered a heart attack, a decisive experience which he likened to "instant psychoanalysis".

The first picture to appear after this collapse, at the beginning of 1958, was a narrow vertical format measuring 219 by 15 cm, and entitled *Outcry*, which took up where *The Wild* left off. With this picture Newman laid the foundation of the group of works entitled *Stations of the Cross – Lema Sabachthani*, which is regarded as one of his most important works, and which the art historian Franz Meyer went as far as to describe as the "Sistine Chapel of the 20th century".

In February 1958, Newman began work on the first two pictures, before they were actually thought of as parts of a cycle or "a theme with variations", as he wrote in 1966: "I began these paintings eight years ago the way I begin all my paintings – by painting. It was while painting them that it came to me (it was the fourth one) that I had something particular here. It was at that moment that the intensity that I felt the paintings had, made me think of them as the Stations of the Cross. It is as I work that the work itself begins to have an effect on me. Just as I affect the canvas, so does the canvas affect me."

In Christian iconography, the Stations of the Cross, from the Condemnation to the Entombment, have since the 17th century numbered 14 scenes of suffering, and Newman followed this tradition with his own 14-part version, without illustrating the stations individually. Newman reduced his media to the colours black, and in three of the *Stations*, white, in addition to the unprimed identically sized canvas and adhesive tape, in order to create sharp-edged or frayed zips. From this limited instrumentarium Newman obtained a broad spectrum of aesthetic effects. In 1966 he extended the cycle with the addition of a final work, *Be II* (1961–1964); this had already been exhibited at the Allan Stone Gallery in 1962 under the title *Resurrection*, and attributed to Newman's friend Tony Smith; however it was only completed in 1964.

The subtitle of the group of works points back to Newman's *Outcry* of 1958. In a statement issued on the occasion of the presentation of *Stations of the Cross*, Newman wrote: "*Lema Sabachthani* – why? Why did you forsake me? To what purpose? Why? This is the Passion. This outcry of Jesus. Not the terrible walk up the Via Dolorosa, but the question that has no answer." This was a renewed defence by the artist of the claim made by the content of his artistic project. At the same time, he emphasized the autobiographical and self-reflexive dimension of the cycle by declaring that the title was not to be understood literally, but as a metaphor for his feelings while painting the pictures: every station of the Cross was also a station in his personal life and his life as an artist.

Stations of the Cross, installation view, Solomon R. Guggenheim Museum, New York 1966

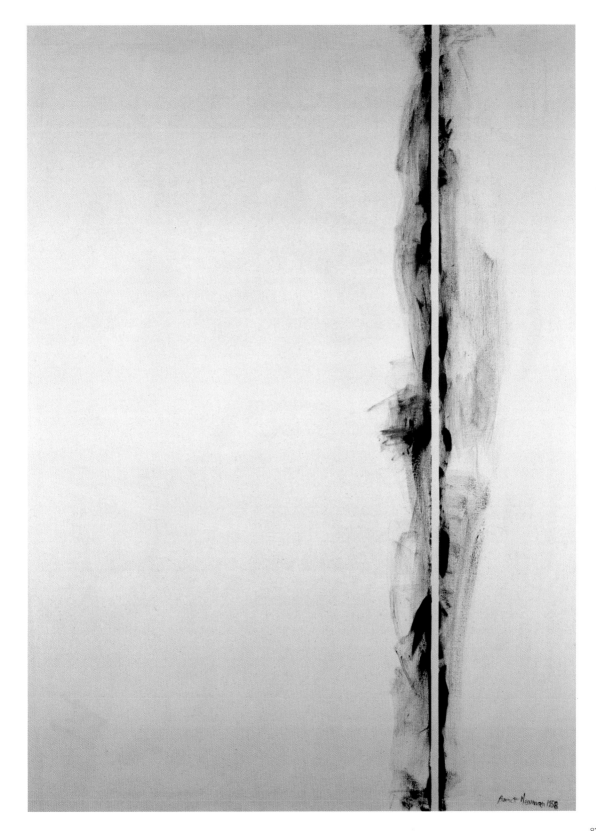

Pompeii

Oil on canvas, 214 x 132.7 cm
London, Tate Modern

After more than forty years teaching art, in, among other places, renowned colleges in New York and Provincetown, Massachusetts, in 1958 Hans Hofmann closed down his institutes and began to devote himself primarily to his own painting. In the Abstract Expressionist art scene Hofmann was perceived as an influential teacher rather than as an artist, which may have contributed to the fact that only when he was in his sixties was his work to be seen more frequently in solo exhibitions.

Irving Sandler has pointed to the fact that this delayed reception was also due to the cultural climate in New York during the 1940s and 50s: for one thing, Hofmann's painting in the eyes of curators and younger fellow artists betrayed too much of the influence of the French legacy of Cubism and Fauvism; for another, his optimistic artistic and textual statements hardly fit into a context in which artists such as Adolph Gottlieb, Barnett Newman and Mark Rothko were continually emphasizing that the subjects of their art were "tragic and timeless". "Throughout his long career as a painter, teacher, and theorist, one would be hard pressed to find a stroke or word that is melancholy, bitter, ironic, or disenchanted," remarked William Seitz, the curator of a comprehensive Hofmann retrospective in the Museum of Modern Art in 1963. Hofmann was "*the* hedonist of Abstract Expressionism, robust and generous", a description which Irving Sandler doubtless used in allusion to another European "hedonist": Henri Matisse, with whom Hofmann had studied in Paris.

In his 1948 essay "Search for the Real in the Visual Arts" Hofmann created the painterly principle with which his name is still linked today: "Depth, in a pictorial sense, is not created by the arrangement of objects one after another toward a vanishing point, in the sense of the Renaissance perspective, but on the contrary (and in absolute denial of this doctrine) by the creation of forces in the sense of *push and pull*." As there was no way of creating "real depth" in painting by boring a hole in the canvas, Hofmann rejected any perspective illusionism and demanded instead that the flatness of the two-dimensional canvas be emphasized. Spatial effects should be generated exclusively through colour contrasts, as in *Pompeii*: flat rectangles in dissonant red, orange and magenta hues contrast with accents in green, blue, and turquoise, and create a visual dynamic without disturbing the impression of a wall-like surface. The title of the picture and the dominance of the warm colour tones point to the ancient city on the Mediterranean which was covered in volcanic ash when Mount Vesuvius erupted in 79 AD.

One of the most important sources for Hofmann's view of art was an 1893 text by the German sculptor Adolf von Hildebrand, "Das Problem der Form in der bildenden Kunst" (The Problem of Form in the Visual Arts), which Hofmann introduced to his American public. Hofmann's teaching activities not only exerted an influence on the practice of a younger generation of American artists, but also largely shaped formalistic art criticism, which found its most pronounced expression in the writings of Clement Greenberg. Greenberg pointed expressly on a number of occasions to the inspirations he had derived from Hofmann's lectures.

"Art is not only the eye; it is not the result of intellectual considerations. Art is strictly bound to inherent laws dictated by the medium in which it comes to expression. In other words, painting is painting, sculpture is sculpture, architecture is architecture."

Hans Hofmann

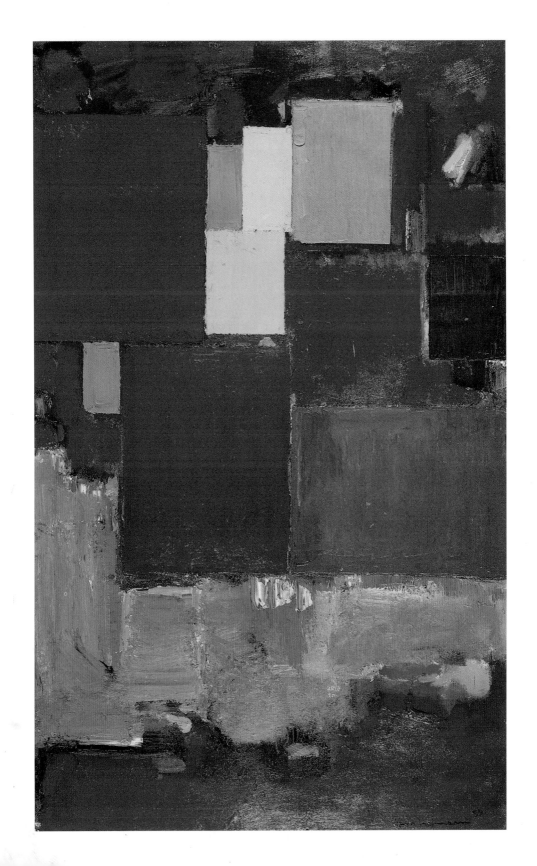

documenta II

Oil and acrylic on cotton, 174 x 176.3 cm
Private collection

b. 1922 in New York,
d. 1997 in New York (USA)

On what must be the most famous group photograph of the Abstract Expressionists, taken by Nina Leen and published in January 1951 in "Life Magazine", Theodoros Stamos can be seen sitting as the youngest protagonist among the so-called "Irascibles" in the front row on the left. They were protesting against a planned survey exhibition if American painting at the Metropolitan Museum, which they regarded as excluding "advanced art".

The son of Greek immigrants, Stamos had at first studied sculpture at the American Artists School, but in 1939, self-taught, had begun to devote himself entirely to painting. His first solo exhibition took place in 1943 at the Wakefield Gallery, which at the time was run by Betty Parsons, and brought him into contact with artists such as Adolph Gottlieb and Barnett Newman, in whose circle his work was to develop in the succeeding years. Thus Stamos, together with Hans Hofmann, Ad Reinhardt, Mark Rothko and Clyfford Still, took part in the 1947 group exhibition "The Ideographic Picture", which Newman curated for the Betty Parsons Gallery. "Spontaneous, and emerging from several points," declared Newman in his introductory text to the exhibition, "there has arisen during the war years a new force in American painting that is the modern counterpart of the primitive art impulse." This "modern counterpart of the primitive art impulse" manifested itself during the 1940s not least through the choice of mythological motifs, such as we see in Stamos' 1947 picture *Ancestral Worship*.

The 1959 painting *documenta II* is part of Stamos' extensive "Field" series (1954–1961). The term "field" refers to one of the two main currents within Abstract Expressionism, Action Painting and Color Field Painting; the latter was boosted in particular by Clement Greenberg's influential 1955 essay "'American-type' Painting". The large format *documenta II* is characterized by a simplified, almost geometric composition, which divides the surface of the picture vertically into two monochrome halves. The swirling atmospherically translucent application of paint is reminiscent of elements such as fire and air. Stamos himself emphasized in 1958: "There is a strong and conscious relationship between my work and nature, which finally manifests itself in an impersonal expression."

Unusually, Stamos named his picture after the important documenta II exhibition of international contemporary art held in the German city of Kassel in 1959, at which he was represented. The year before he had taken part in the international touring exhibition "The New American Painting" (1958–59), which had been organized by the Museum of Modern Art in order to demonstrate the superiority of American painting over its contemporary European rivals. Also in 1959, Mark Tobey became the first 20th-century American painter to win the Painting Prize at the Venice Biennale.

At the second documenta, the International Program of the Museum of Modern Art presented numerous exponents of Abstract Expressionism, who attracted lively – and overwhelmingly positive – attention. There were some critical voices, however, who noted that the majority of the exhibits had only been produced immediately before (and on the occasion of) the influential major international exhibition, and saw this as evidence of increasing entanglement between public art institutions and the art market.

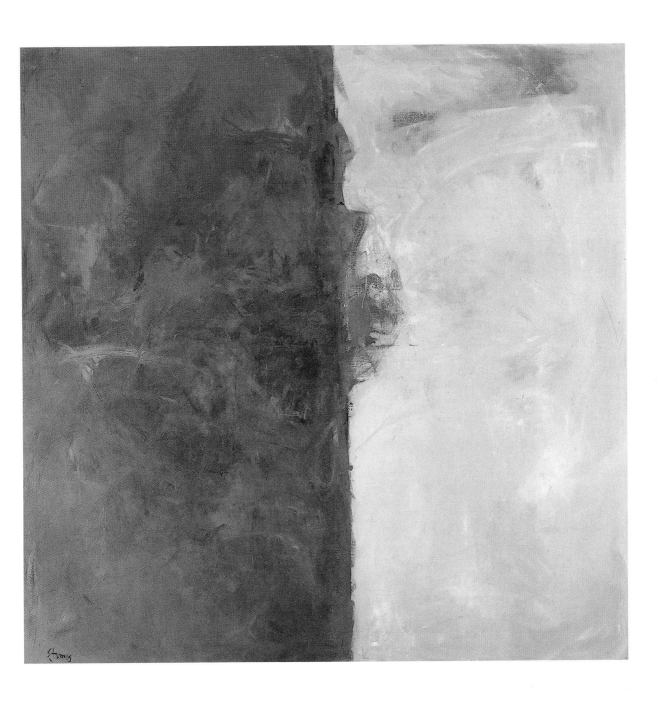

abstract painting No. 34

Oil on canvas, 153 x 152.6 cm
Washington, D. C., National Gallery of Art, Gift of Mr. and Mrs. Burton Tremaine

From 1954, Ad Reinhardt definitively reduced the coloration of his geometric abstractions to shades of black. In 1960 he finally arrived at a pictorial design to which he was to devote himself exclusively until his death in 1967: square canvases measuring sixty by sixty inches (152.4 cm), whose surface is divided into nine equal squares – a composition, which Reinhardt regarded as "no' composition". Reinhardt related the format to the approximate body measurements of a beholder standing in front of the canvas with outstretched arms.

The lightless, contrastless coloration of the fields is minimally differentiated by additions of green, blue and brown; the matt quality of the paint excludes any reflection of the surroundings in the surface of the picture. *Abstract Painting No. 34* is one of the paintings to be based on a grid of differently coloured squares, divided by a horizontal green stripe. The oil-paint was applied manually with a brush in such a way that no brush-strokes can be discerned. If pictures were damaged at exhibitions, Reinhardt overpainted them, with the result that they can no longer be unambiguously dated.

When the New York Museum of Modern Art acquired one of the "black paintings" in 1963, Reinhardt received from the museum a questionnaire with the request to give his views on the importance of this group of works. Reinhardt defined this in a detailed statement as "the most extreme, ultimate, climactic reaction to and negation of" a tradition of Abstract art, which embraces Cubism and the work of Piet Mondrian, Kasimir Malevich, Josef Albers and Burgoyne Diller. Through his insistence on what his painting was not, Reinhardt tried to get the partly contradictory interpretations of his pictures as "neo-Classical", "Romantic", "purist", "avant-garde", "religious" and so on to run into the sand.

While Reinhardt declared that he was leading an artistic tradition to its climax through negation, at the same time with his "black paintings" he was exerting pioneering influence on a younger generation of artists and was assigned in this connection the controversial role of a "forerunner" of Minimal Art and Concept Art. Thus the philosopher of art Richard Wollheim, for example, in his 1965 essay "Minimal Art" asserted that in Reinhardt's works, the art content was minimal, as the works in question were to a very high degree undifferentiated. In 1969 Joseph Kosuth, in his essay "Art After Philosophy", which is regarded as the manifesto of an analytical tendency within Concept Art, quoted the first lines of Reinhardt's 1962 text "Art as Art": "The one thing to say about art is that it is one thing. Art is art-as-art and everything else is everything else. Art-as-art is nothing but art. Art is not what is not art."

Kosuth's use of the short quote taken out of context, which is followed by quotes from other artists and theoreticians, is nothing less than a productive "mistaken interpretation" of Reinhardt's utterances: unlike Kosuth, he was concerned solely with a negative definition of Abstract painting. "Art can be corrected, but, alas, the public cannot." This bon mot was attributed by the critic and artist Elaine de Kooning in a 1957 article for "ArtNews" to a fictitious artist named Adolf M. Pure, doubtless Ad Reinhardt's alter ego.

Ad Reinhardt, 1966

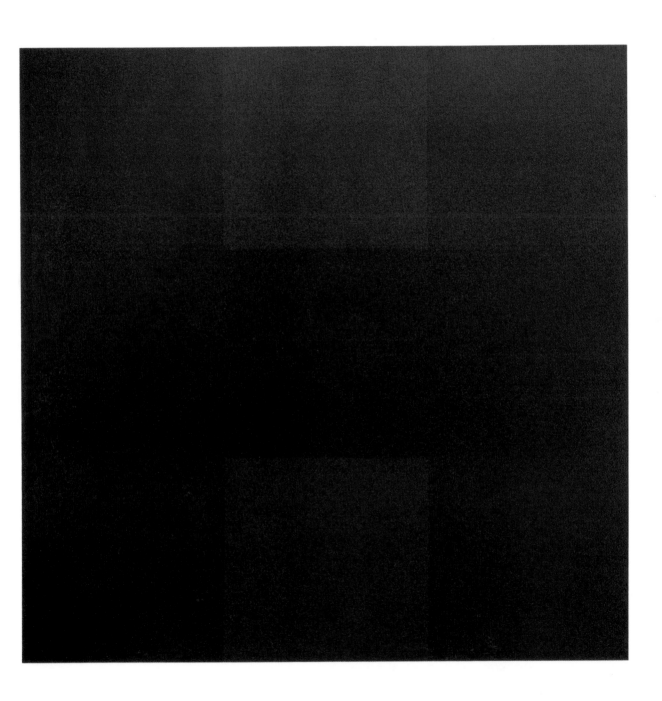

rothko chapel

3 of 14 paintings (including 3 triptychs), west, north-west and north wall paintings, oil on canvas
Houston, The Menil Collection
==

From the late 1950s, Mark Rothko's struggle for "the life my pictures will lead out in the world" took a new course. By the time of his death in 1970, Rothko had developed three (commissioned) room-related groups of works. For his one-man show at the Sidney Janis Gallery in 1955 he had already arranged for the formats of his pictures so that in height they matched that of the wall, and in breadth partly blocked the doorways. The close relationship between the dimension of the picture and the pictorial design of the walls or of whole rooms can be traced right back to Rothko's early work. In 1932 he painted a small panel entitled *Interior*, which depicts a view of a two-storey wall, divided into six colour-fields; in 1938 and 1940 Rothko designed murals for a post-office in Rochelle, New York, and for the Social Security Building in Washington, D.C., which however were never executed.

In June 1958 Rothko was commissioned to execute murals for the Four Seasons Restaurant in New York's Seagram Building, designed by the architects Philip Johnson and Mies van der Rohe. In his studio, Rothko had a wooden structure built, which corresponded to the spatial situation in the restaurant, and developed a type of picture that was new for him: approximately square or horizontal rectangular canvases in dark red and brown tones. Standing out against monochrome backgrounds are frames with single or double vertical openings, which, according to Rothko, are supposed to be reminiscent of closed doors or windows; as one exemplar, he named the blind windows in Michelangelo's Biblioteca Laurenziana in Florence. In the summer of 1959, Rothko interrupted work on the project to undertake a journey to Europe; in the ancient murals of Pompeii he discovered a close relationship with his own art. After his return, he visited the Four Seasons Restaurant in 1960 and because he thought the ambience would reduce his art to mere decoration, saw himself constrained to turn down the commission; the pictures already executed were later exhibited in different arrangements and contexts.

The only time Rothko himself installed pictures in a particular room was when he presented the *Harvard Murals* in 1962–63 to the oldest university in the United States, which he conceived for the Dining Hall at the Holyoke Center. The group consists of a triptych and two single pictures with uniform deep-red backgrounds. Rothko explained to the President of Harvard, Nathan Pusey, that the triptych referred to the Passion of Christ on Good Friday, while the two lighter pictures referred to Easter and the Resurrection. In this case too, Rothko ultimately found the circumstance that the Dining Hall was furnished to be a disturbing factor. In addition, there was no satisfactory way of regulating the sunlight, which over the years led to the light-sensitive pigments fading, so that in 1979 the pictures were removed.

As early as 1957 Rothko had begun increasingly to work with darker colours; a year later, he emphasized that "a clear preoccupation with death" was one of the "ingredients" of his painting. A dark palette also characterizes Rothko's last major group of works, which was commissioned by the collectors Dominique and John de Menil: the interdenominational *Rothko Chapel*, which was built according to his ideas and belongs to Rice University in Houston, Texas. The pictures are his first to evince sharp outlines for the colour-fields; these, and the similarly new monochrome panels enhance the aesthetic austerity of the design. The chapel was consecrated posthumously in 1971 after Rothko's suicide.

Seagram Murals, 1958

To stay informed about upcoming TASCHEN titles, please request our magazine at www.taschen.com/magazine or write to TASCHEN America, 6671 Sunset Boulevard, Suite 1508, USA-Los Angeles, CA 90028, contact-us@taschen.com, Fax: +1-323-463.4442. We will be happy to send you a free copy of our magazine which is filled with information about all of our books.

© 2006 TASCHEN GmbH
Hohenzollernring 53, D–50672 Köln
www.taschen.com

Editorial coordination: Sabine Bleßmann, Cologne
Design: Sense/Net, Andy Disl and Birgit Reber, Cologne
Production: Tina Ciborowius, Cologne
Translation: Michael Scuffil, Leverkusen

Printed in Germany
ISBN-13: 978-3-8228-2970-7
ISBN-10: 3-8228-2970-6

Photo credits:
The publishers would like to express their thanks to the archives, museums, private collections, galleries and photographers for their kind support in the production of this book and for making their pictures available. If not stated otherwise, the reproductions were made from material from the archive of the publishers. In addition to the institutions and collections named in the picture descriptions, special mention is made of the following:
© Archiv für Kunst und Geschichte, Berlin: p. 7, 14, 19/Artothek: p. 85/The Art Institute of Chicago, Chicago: p. 35/Bridgeman Giraudon: p. 13, p. 16 (left), 17, 18, 64/Corcoran Gallery of Art, Washington, D.C.: p. 65/K20 – Kunstsammlung Nordrhein-Westfalen, Düsseldorf: p. 16 (left), 63/Photo © 1986 The Metropolitan Museum of Art: p. 29/Modern Art Museum of Fort Worth, Fort Worth: p. 67/ Munson-Williams-Proctor Arts Institute, Utica: p. 38/Image © 2005 Board of Trustees, National Gallery of Art, Washington, D.C.: p. 10, 87/The Phillips Collection, Washington, D.C.: p. 73/Photo © AP/Wide World Photos: p. 12 (right)/Photo Berenice Abbott, Courtesy of Lillian Kiesler © Solomon R. Guggenheim Museum, New York: p. 12 (left)/Photo Cecil Beaton, Courtesy Vogue © 1951 (renewed 1979) Condé Nast Publications, Inc.: p. 22 (right)/Photo Rudolph Burckhardt: p. 56/Photo Courtesy Hackett-Freedman Gallery, San Francisco: p. 15 (right)/ Photo Courtesy the artist and Hauser & Wirth, Zürich, London: p. 25/Photo Estate Martin Kippenberger/Galerie Gisela Capitain, Köln: p. 24 (right)/Photo Lawrence Larkin © Archives of American Art, Smithsonian Institution: p. 76/Photo Nina Leen © Time Life Pictures/Getty Images: p. 4/The Menil Collection: p. 95 (Photo Hickey and Robertson)/Photo Hans Namuth © the Estate of Hans Namuth, Peter Namuth, New York: p. 15 (left), 52, 54/Photo Arnold Newman/Getty Images © 1949 TIME Inc.: p. 22 (left)/Photo Privatbesitz: p. 24 (left)/© Photo SCALA, Florenz/The Museum of Modern Art, New York 2005: p. 41, 45, 53, 69, 70/© Photo SCALA, Florenz/Smithsonian American Art Museum, Washington, D.C., 2005: p. 1/Photo Sunami: p. 21 (left)/San Francisco Museum of Modern Art, San Francisco: p. 39, 75/Seattle Art Museum, Seattle: p. 61 (Photo Paul Macpia)/Solomon R. Guggenheim Museum: p. 86 (Photo Robert E. Mates), 93/Tate Gallery, London: p. 89/ Whitney Museum of American Art, New York: p. 20, 59, 79, 83

Reference illustrations:
p. 38: Philip Guston, *Porch No. 2,* 1947, oil on canvas, 158.8 x 109.2 cm, Utica, New York, Munson-Williams-Proctor Arts Institute, Museum of Art/p. 52: Barnett Newman and Betty Parsons in front of Newmans *The Wild,* 1951/p. 54: Jackson Pollock painting *Autumn Rhythm: Number 30,* 1950/p. 56: Elaine and Willem de Kooning in the atelier, New York, early 1950s/p. 64: Josef Albers, *Variation in Red and Orange around Pink, Ochre, Plus Two Reds,* 1948, oil on canvas, 50.8 x 76.8 cm, Private collection/p. 68: Jackson Pollock, *Totem Lesson 2,* 1945, oil on canvas, 182.9 x 152.4 cm, Canberra, National Gallery of Australia/p. 70: Robert Motherwell, *Ink Sketch (Elegy No. 1),* 1948, ink on paper, 26.8 x 21.6 cm, New York, The Museum of Modern Art/p. 72: The Rothko Room, installation, The Phillips Collection, Washington, D.C./p. 74: Philip Guston, *Sleeping,* 1977, oil on canvas, 213.4 x 175.3 cm, Private collection/p. 76: Jackson Pollock and Lee Krasner in the atelier, 1949/p. 80: Helen Frankenthaler, *Mountains and Sea,* 1952, oil on unprimed canvas, 220 x 297.8 cm, Washington, D.C., National Gallery of Art/p. 86: Barnett Newman, *Stations of the Cross,* installation view, Solomon R. Guggenheim Museum, New York 1966/p. 94: Mark Rothko, *Seagram Murals,* 1958, Chiba-Ken, Japan, Kawamura Memorial Museum of Art

page 1
FRANZ KLINE
Untitled
c. 1959, oil on cardboard, 24 x 19 cm
Washington, D.C., Smithsonian American Art Museum

page 2
JACKSON POLLOCK
Shimmering Substance (Sounds in the Grass series)
1946, oil on canvas, 76.3 x 61.6 cm
New York, The Museum of Modern Art, Mr. and Mrs. Albert Lewin and Mrs. Sam A. Lewisohn Funds

page 4
The Irascibles
From left to right, seated: Theodoros Stamos, Jimmy Ernst, Jackson Pollock, Barnett Newman, James Brooks, Mark Rothko; standing: Richard Pousette-Dart, William Baziotes, Willem de Kooning, Adolph Gottlieb, Ad Reinhardt, Hedda Sterne, Clyfford Still, Robert Motherwell, Bradley Walker Tomlin